PORCH

by **Brian Vanden Brink**

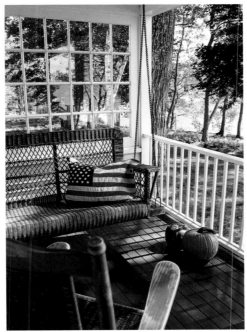

Islesboro, Maine

Text by **Richard Grant**

Down East

*To Ezra and Isaac, who bring such joy
and happiness to their grandparents*

Photographs copyright © 2011

by Brian Vanden Brink

Text copyright © 2011 by Richard Grant

All rights reserved

ISBN 978-0-89272-933-3

Design by Lynda Chilton

Printed in China

Down East

BOOKS·MAGAZINE·ONLINE

w w w . d o w n e a s t . c o m

Distributed to the trade by National Book Network

Library of Congress Cataloging-in-Publication Data

Vanden Brink, Brian, 1951-

 Porch / photographs by Brian Vanden Brink ;

text by Richard Grant. -- 1st ed.

 p. cm.

 ISBN 978-0-89272-933-3 (trade hardcover : alk. paper)

1. Porches. I. Grant, Richard, 1952- II. Title.

 NA7125.V26 2011

 779'.4--dc22

 2011014442

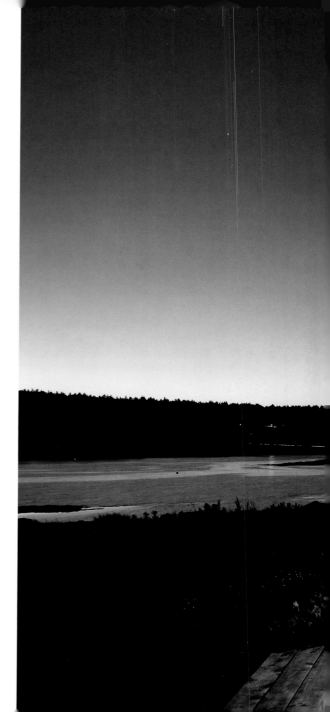

Coastal Maine

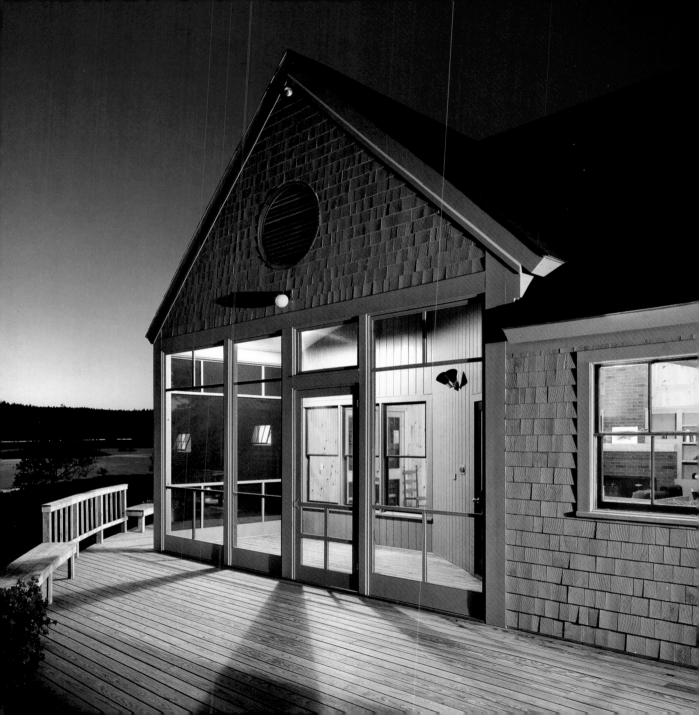

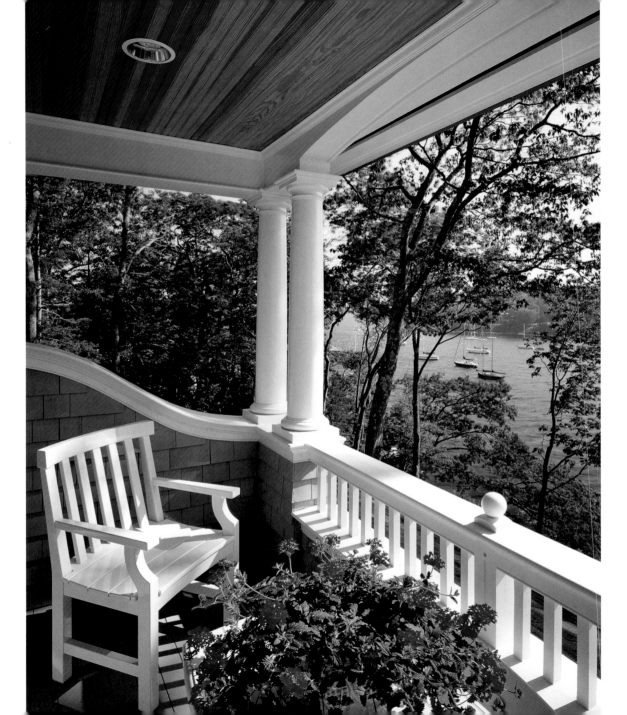

FOREWORD

'm a high-energy guy. Sometimes I find it hard to relax, even while on vacation or in a spot that invites one to just rest and enjoy the peace and quiet. So why do a book on porches, a place that for most folks is synonymous with tranquility and relaxation? The Bible speaks of "every man sitting under his own vine and fig tree" as a symbol of peace and contentment. I see the porch in a similar way, and while I often don't take the time to enjoy porches like that, I do love to *photograph* them. Many of the photographs in this book were done as part of an assignment to shoot a particular house for an architect or magazine. Shooting the porch was an important part of the assignment, because the porch frequently makes best use of the view or shows the reason why a house was sited where it was. These images have often been used as the cover shot for a magazine feature, because they invite an "I wish I were there" kind of response. These photographs have been made over a period of approximately twenty years, and I continue to add to this body of work. They have been among the most frequently requested and published images in my archive and are presented together here for the first time.

Brian Vanden Brink
Camden, Maine

Rockport, Maine

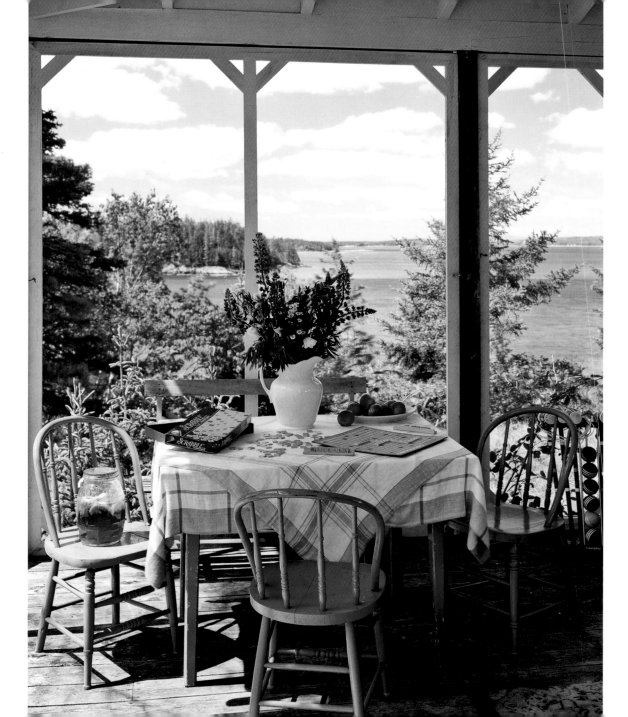

PORCH
by Richard Grant

wasn't always a porch fan. When I set out to build my dream cottage in Maine a few years ago, I didn't plan to have a porch at all. What I had in mind was a nice deck on the side of the house, facing the woods and the wetland and maybe offering a glimpse of Penobscot Bay. The notion of an old-fashioned front porch sprang from the fecund mind of my architectural designer, an energetic young man named Eric Allyn, who seemed to feel that my otherwise unassuming cottage—less than 1,000 square feet on a full stomach, clad in rough-cut board-and-batten siding—could use a modest touch of grandeur.

Eric's first draft was pretty grand, given the limited scope of things. The porch would run along the entire front facade (all 28 feet of it), sheltered by a roof overhang, wrapping around to join up with the deck of my dreams.

Even then, still weeks away from my initial sticker-shock, I sensed that this kind of thing might cost money.

"But Eric," I said. "I don't need a front porch. The front door faces north. There's nothing to look at out there—just the state road and the driveway. I'll never use it."

"You might be surprised," he said.

Of course there is no reasoning with artists, and I'm pretty sure Eric was dressed all in black at the time. We squabbled, I

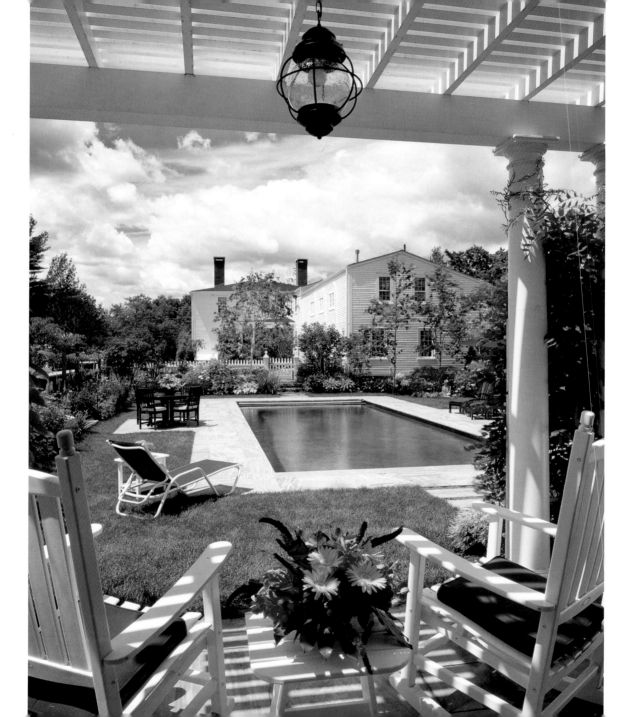

pouted, he hung tough, and eventually we compromised. The porch shrank to twelve feet, still covered. It did seem to make the front of the house less boring.

So now I've got this porch. And in the interest of decorum, as this is a very civilized book, chock-full of mouth-watering but strictly genteel photographs, I will mute my next remark. *I freaking live on this porch.* I feel like I spend my whole summer there. And I don't mean just August, when the idea of a cool, north-facing refuge really comes into its own.

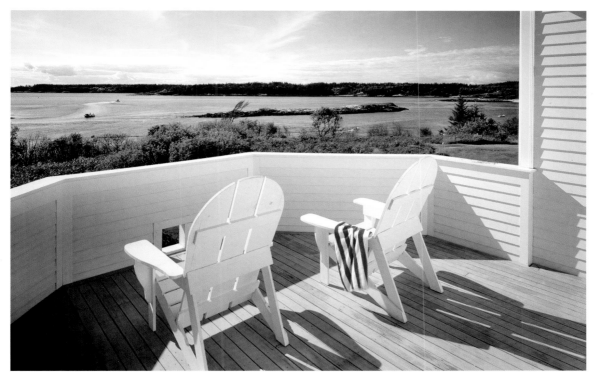

Left: Rockport, Maine; above: Coastal Maine

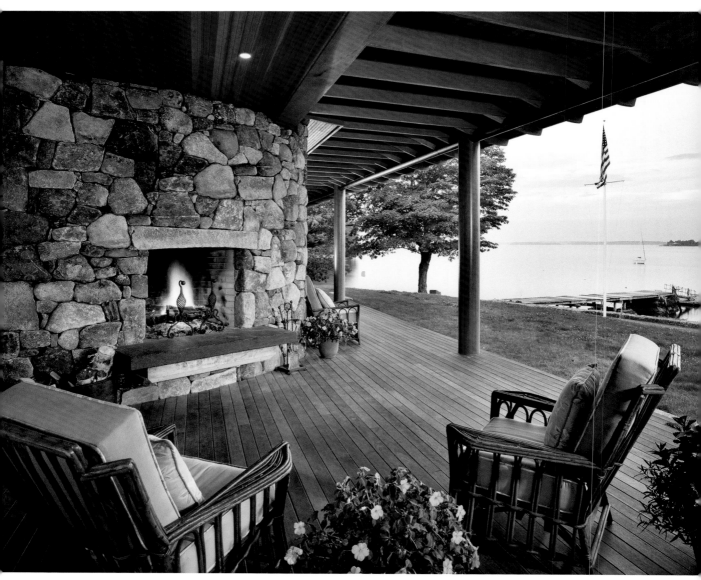

Coastal Maine

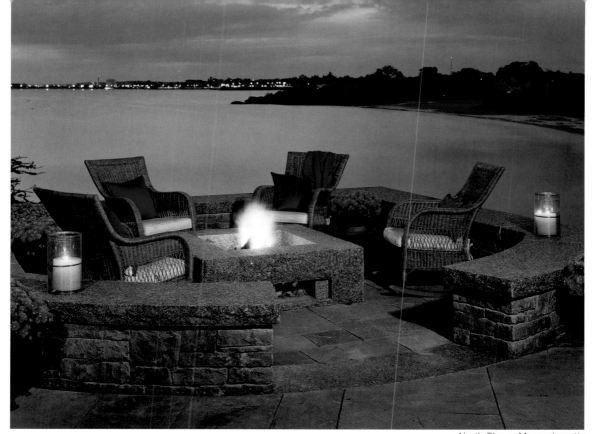

North Shore, Massachusetts

More than that: I need this porch. Wholly apart from its utilitarian value—a place to park snowboards, longboards, sandy sneakers, Bean boots, garden tools, five-gallon buckets of rock salt, and the cat—the porch provides an invaluable, in-between space between indoors and out. I sat out there for nearly an hour one night while a spectacular lightning display flashed and boomed and rain drummed down with Biblical fervor. I sat out there again a few nights later while the indoor thermometer climbed toward 80 and my excellent son Tristan blasted rap

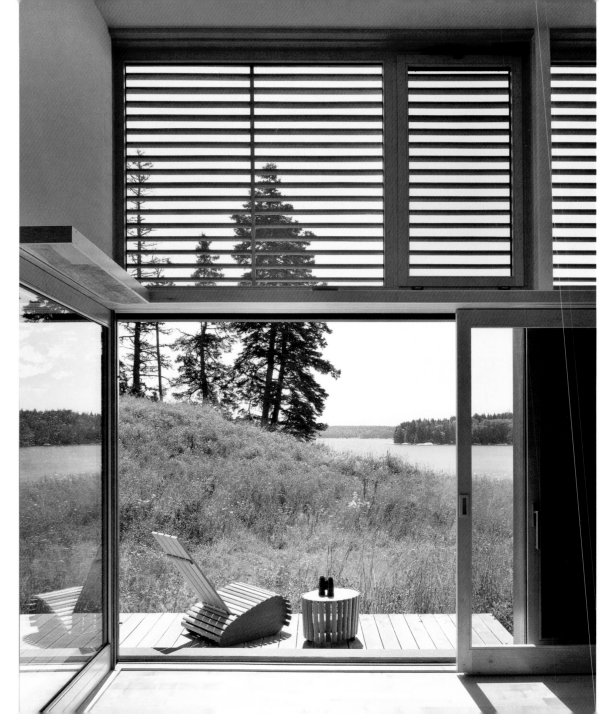

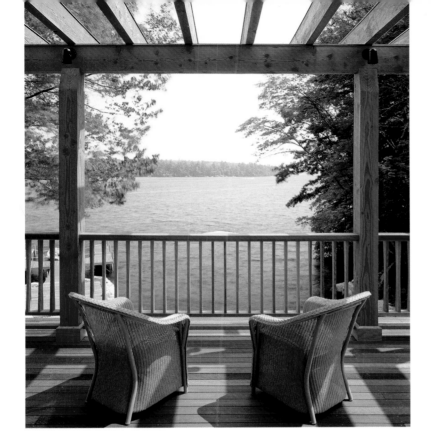

music from the basement. And I'm sitting there now, tapping away on my iPad.

"Nobody thought much about the front porch when most Americans had them and used them," notes Scott Cook of the University of Virginia. "The great American front porch was just there, open and sociable, an unassigned part of the house that belonged to everyone and no one, a place for family and friends to pass the time."

Left: Coastal Maine; above: Western Maine

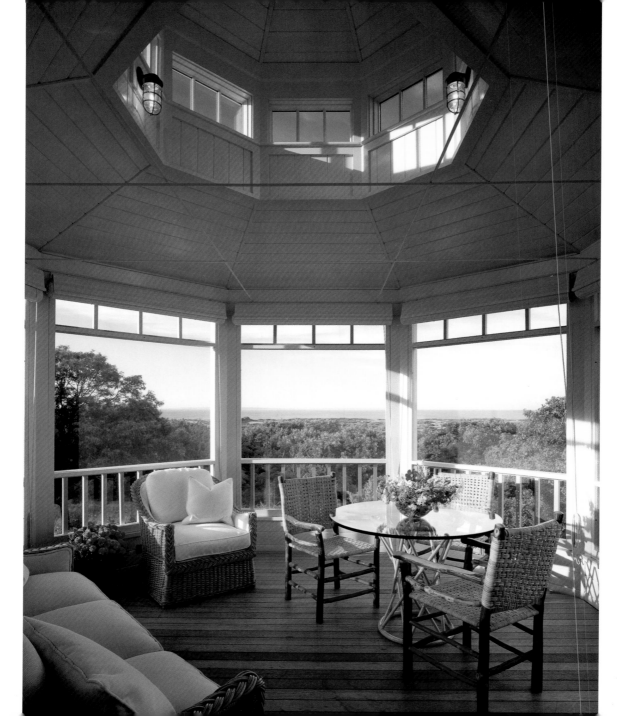

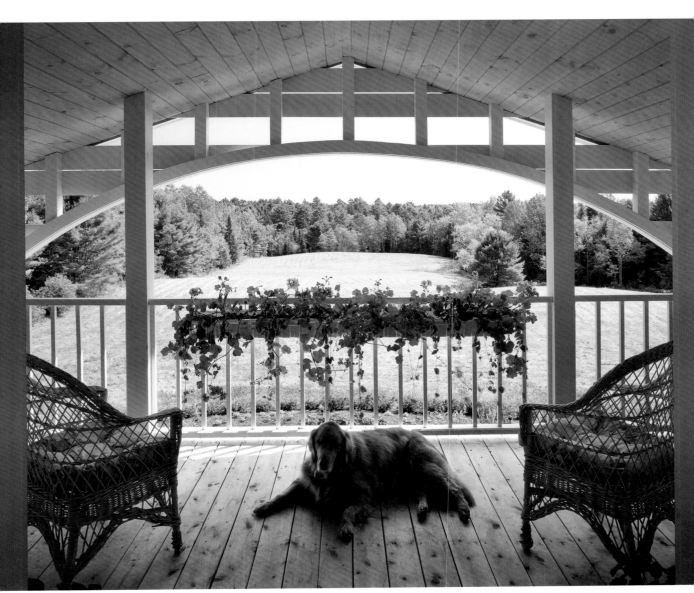

Left: Martha's Vineyard, Massachusetts; above: Freeport,Maine

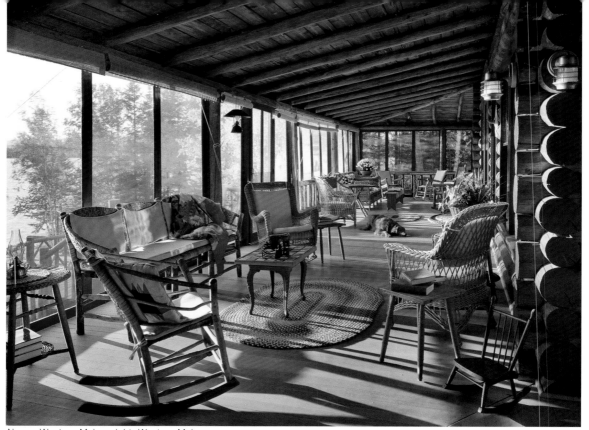

Above: Western Maine; right: Western Maine

I'd say the first part still holds true: Nobody thinks about front porches. If you've got one, it's just there; if you don't, you don't realize anything is missing. Which is a shame, really. So many old houses—and a surprising number of new ones, now that I drive around noticing this—have fine-looking porches that don't see a lot of use.

There seems to have been a period from roughly the Civil War era through the 1920s when the porch was an architectural feature *de rigueur*. We were a different sort of country then: the

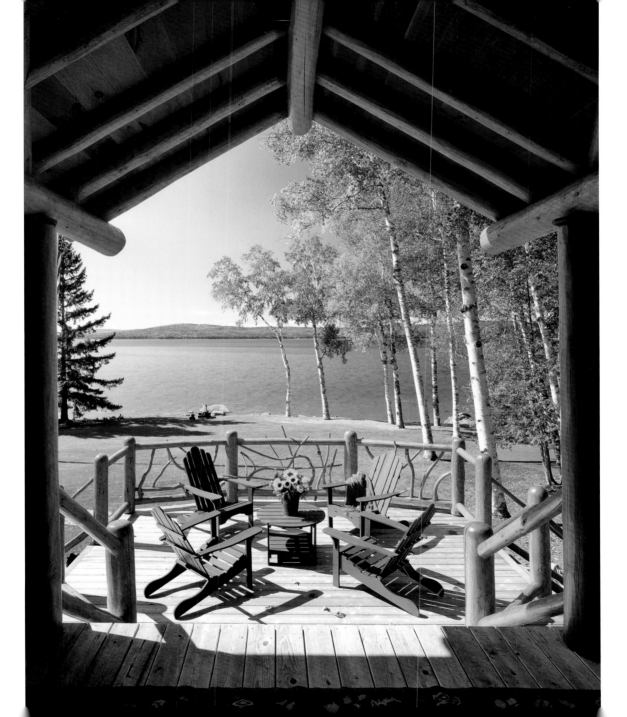

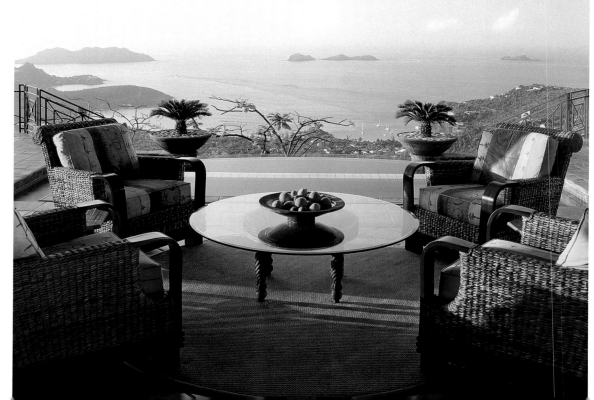

land of the endless front lawn, one property joining boundlessly with the next, connected by roads that people actually walked on. The porch was a physical manifestation of our open, democratic community. You could sit and watch the kids run around and wait for a neighbor to stroll by. The porch was really an outdoor room, not in the precious shelter-magazine sense but on the serious grounds that the family spent much of its collective life out there. Carson McCullers captured this archetypal American scene in *The Heart is a Lonely Hunter*:

> The twilight was blurred and soft…Their Dad leaned back in the chair with his sock-feet on the bannisters. Bill was on the steps with the kids. Their Mama sat on the swing fanning herself with the newspaper. Across the street a girl in the neighborhood skated up and down the sidewalk on one roller skate. The lights on the block were just beginning to be turned on, and far away a man was calling someone.

Times have changed beyond recall, I suppose. Today, as a society, we're all about the deck. We've moved from the front yard to the back, from shared, semi-public space to concealed, private sanctuary. Our reasons are understandable and not to be scorned. But there are other modes of living.

In these pages, through Brian Vanden Brink's wide-ranging and irresistible images, we can pause to consider the possibilities. They are vast. They are beautiful, inspiring, and often

St. Barths, French West Indies

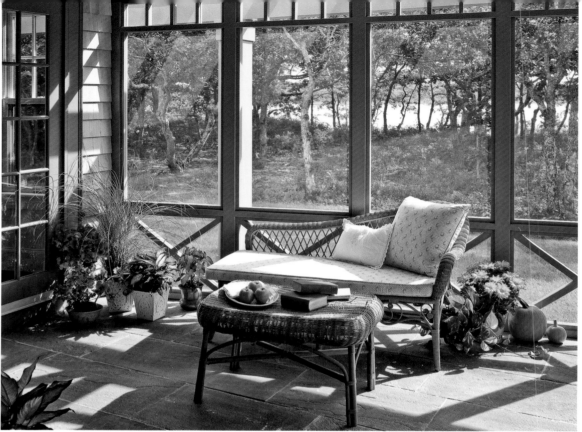

Above: Martha's Vineyard, Massachusetts;
right: Chebeague Island, Maine

downright seductive. And at the same time—unlike many of our dream-house fantasies—porches are down-to-earth, attainable, and eminently American. There is a porch style for every house, every temperament, every budget.

I hope you'll revel in this journey to the land of the possible dream. ◆

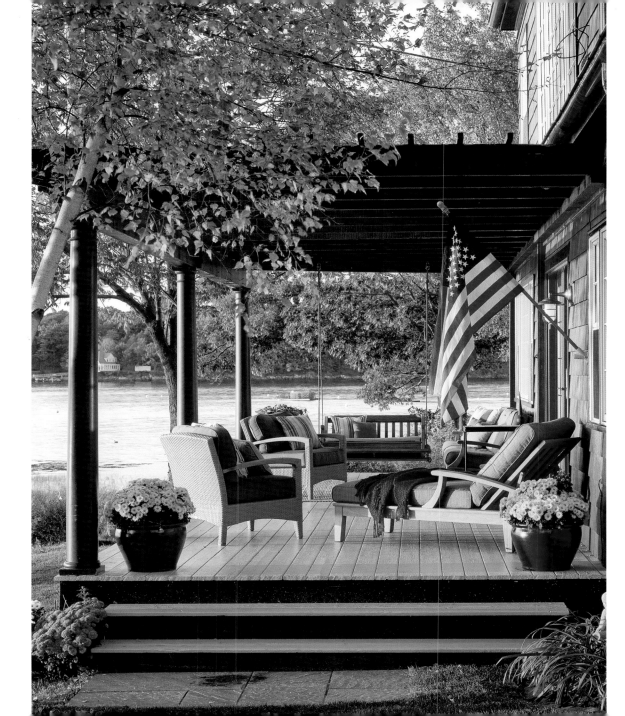

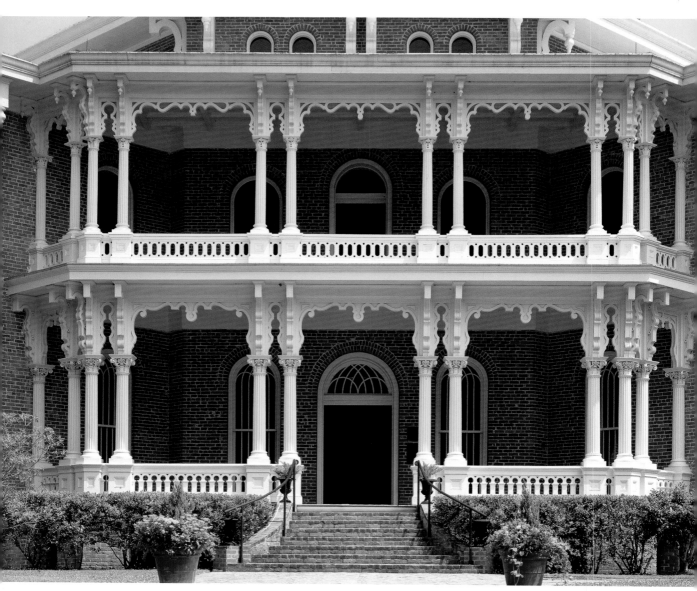

Above: Natchez, Mississippi; right: Cape Cod, Massachusetts

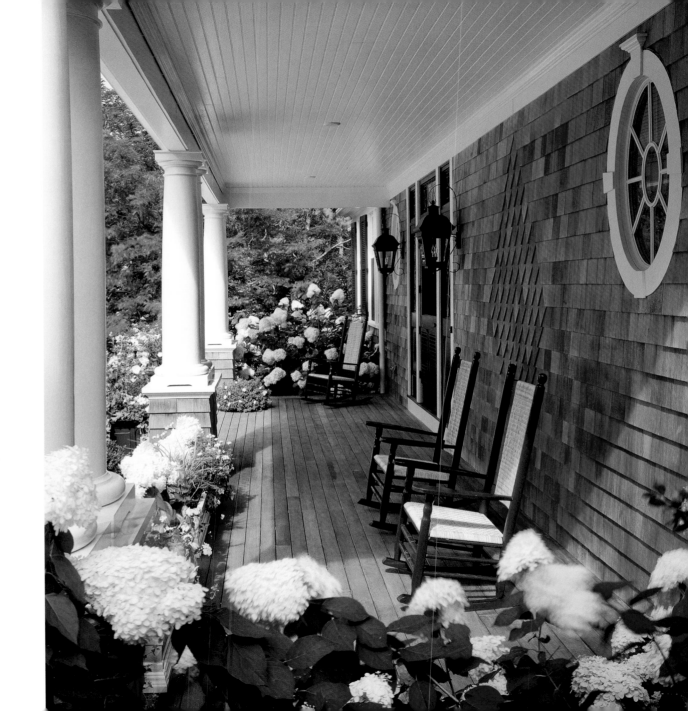

Porches can serve
as galleries: quiet set-
tings where dramatic
plantings, beautiful
furniture, collections of
driftwood or stones or
lobster buoys can be
displayed and appreci-
ated. Weathered wood
makes a classy but
unaffected backdrop for
everything from found
objects to fine art.

Yarmouth, Maine

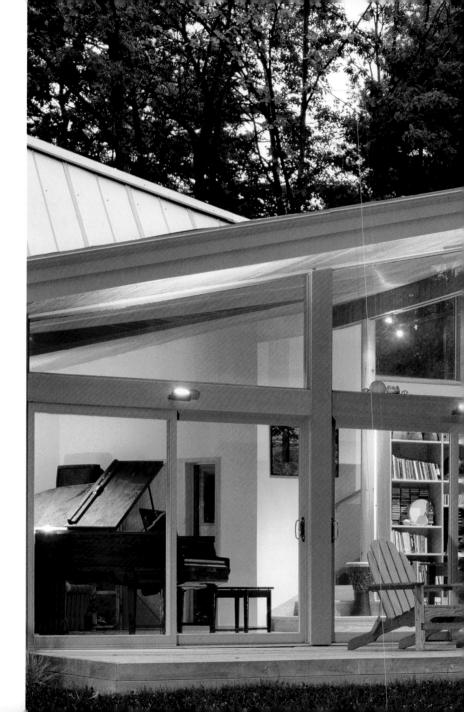

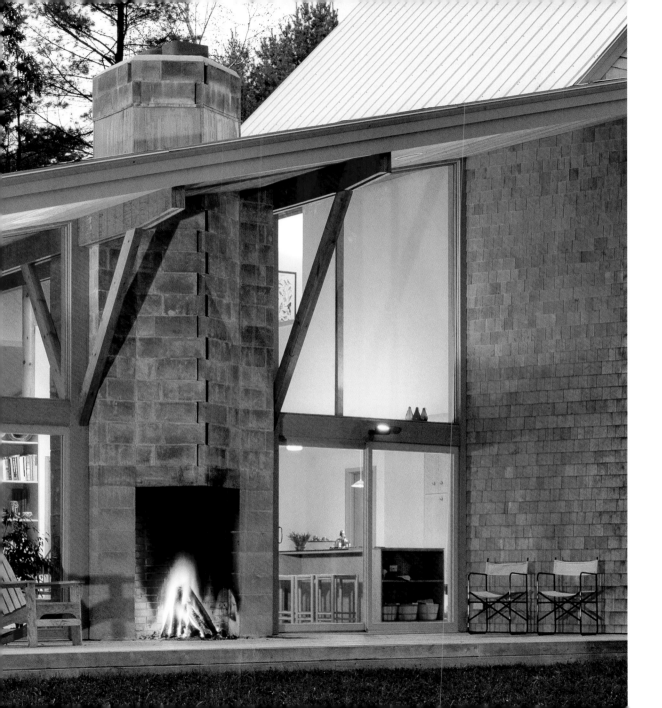

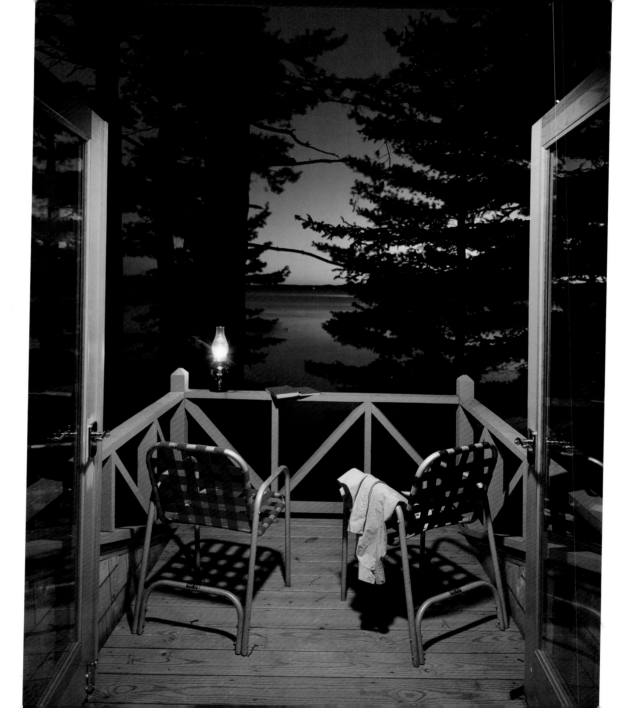

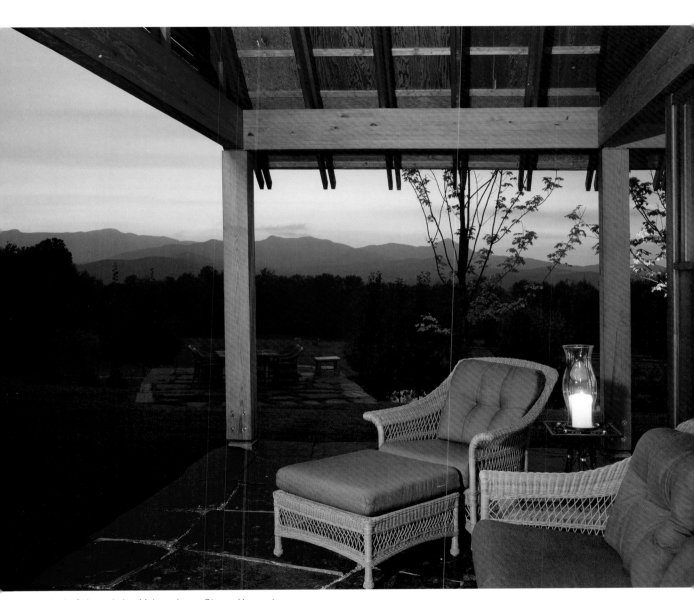

Left: Sebago Lake, Maine; above: Stowe, Vermont

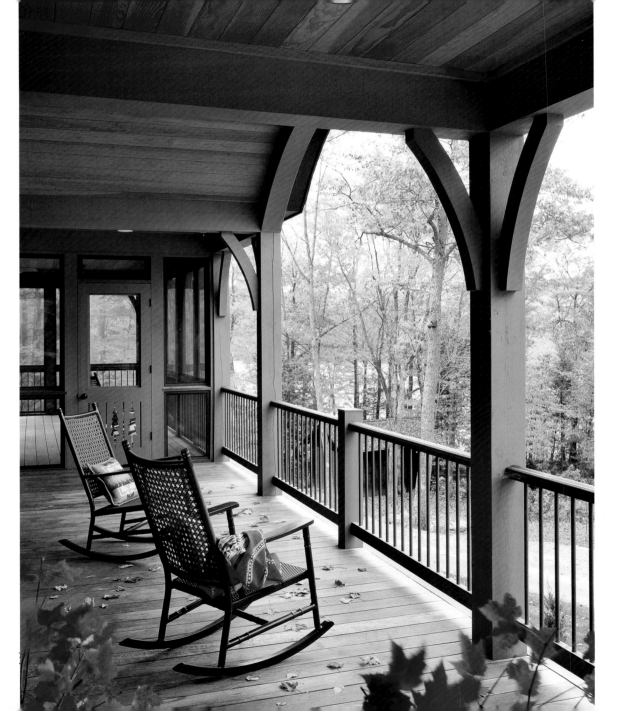

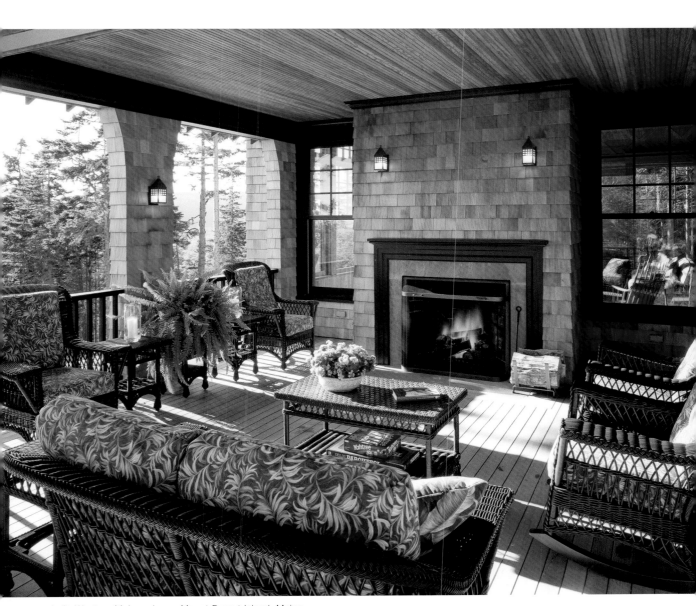

Left: Western Maine; above; Mount Desert Island, Maine

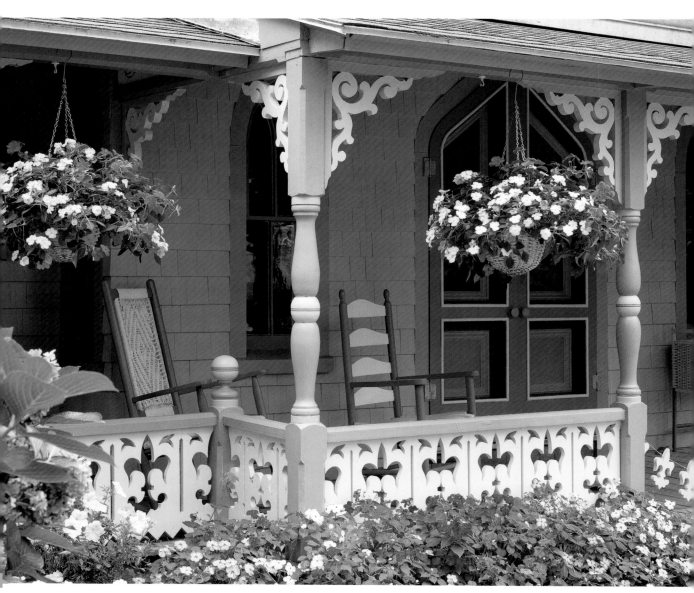

Oak Bluffs, Martha's Vineyard, Massachusetts

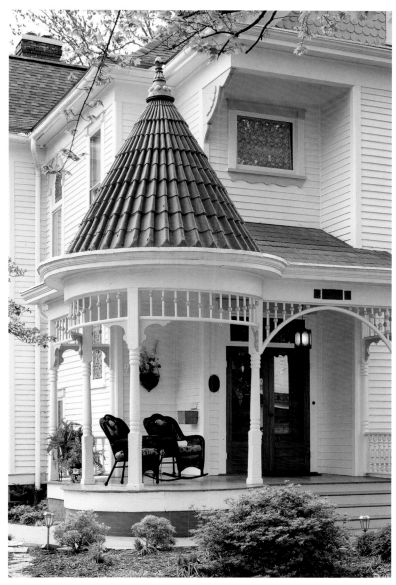

Carmi, Illinois

One of the oldest versions of the American porch arose in nineteenth-century religious "camp meetings"—ad hoc summer villages composed of tiny Carpenter Gothic cottages clustered tightly together around a meeting hall and a broad green common. The houses themselves were no more than functional, one-over- one boxes—but the porches! That's where all the excitement was. Pious austerity flew out the window as neighboring households vied for the most fanciful woodwork, the gaudiest micro-gardens...all to the greater glory of God, of course.

A porch should be,

above all else, a living space, a place that actually gets used. It needn't be larger or grander than necessary. It shouldn't be tacked on just because it looks cool, or stately, or sophisticated. If you're planning a porch, think of how it relates to the rest of the house, the flow of your life, the times you'll actually be out there. A porch off the kitchen, for example, might get more use than a porch out front. If you're home mostly in the evening, a west-facing porch will catch the last bit of sun. More enclosure means greater shelter and comfort.

Western Maine

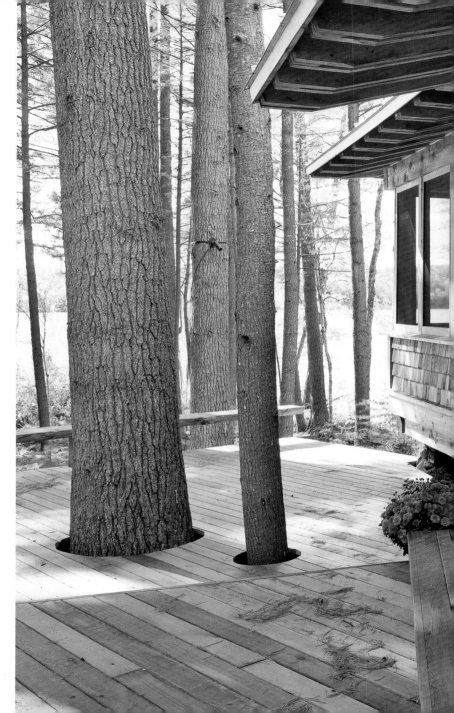

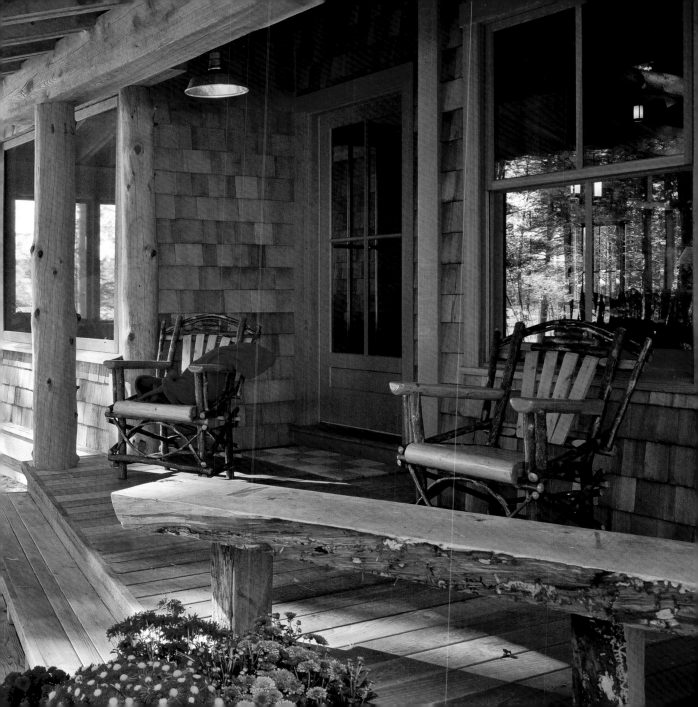

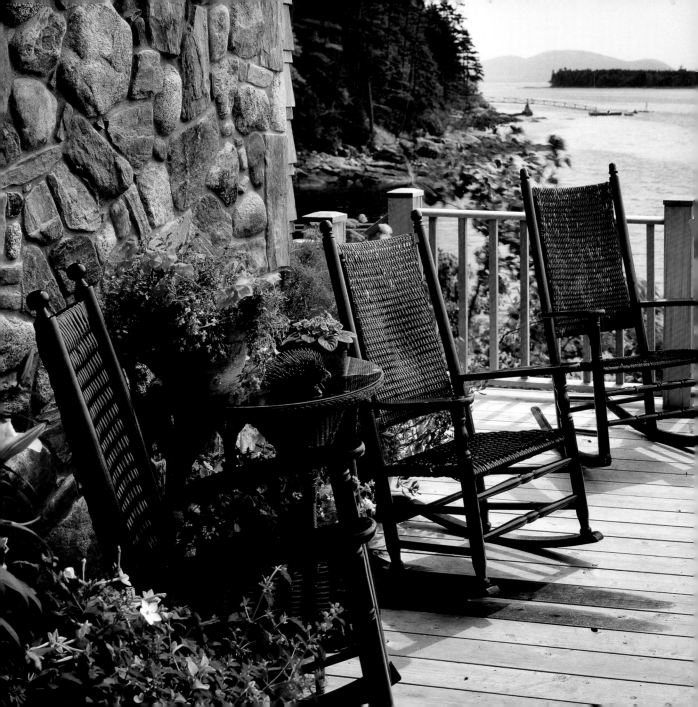

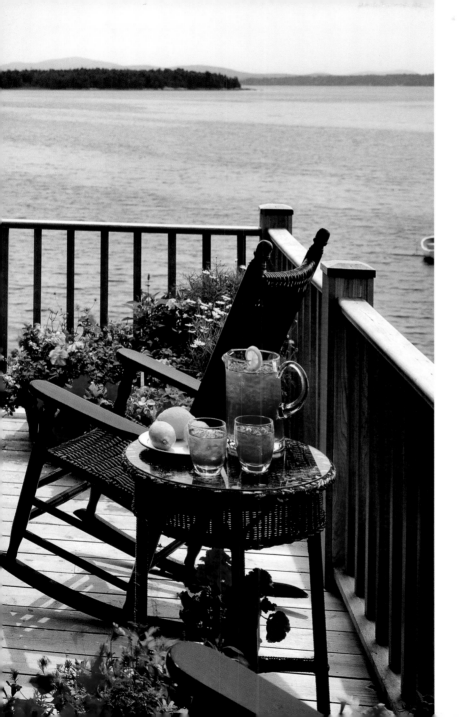

When we look at a porch, our eyes go immediately to the chairs—the traditional Adirondack, the cedar or redwood bench, the *chaise longue,* the wicker settee—but there's no need to feel bound by established conventions. Yard-sale finds, former dining-room chairs, church pews, rustic handmade wooden seating of every description, all jostle happily in an outdoor setting. The one important principle is that of proportion: a porch may be cozy but it should not feel crowded. Space should be left free for walking, for pets, for kids' toys, and just to obviate any sense of confinement.

Mount Desert Island, Maine

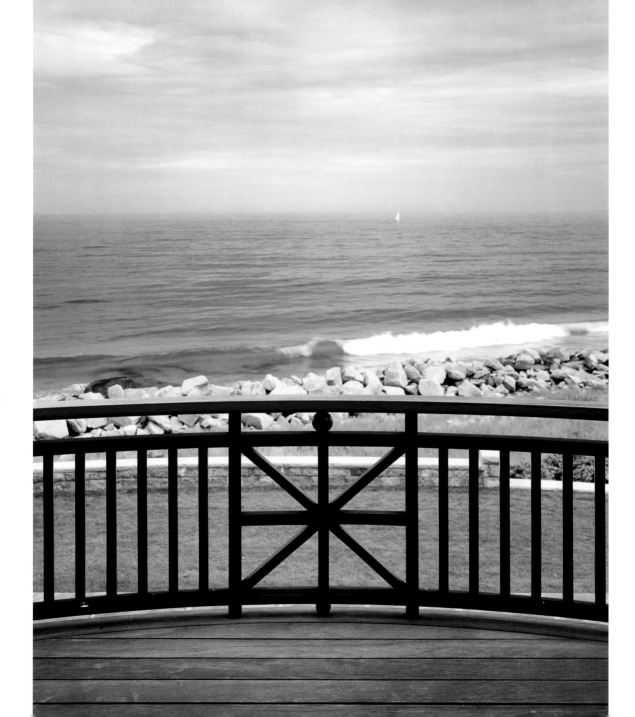

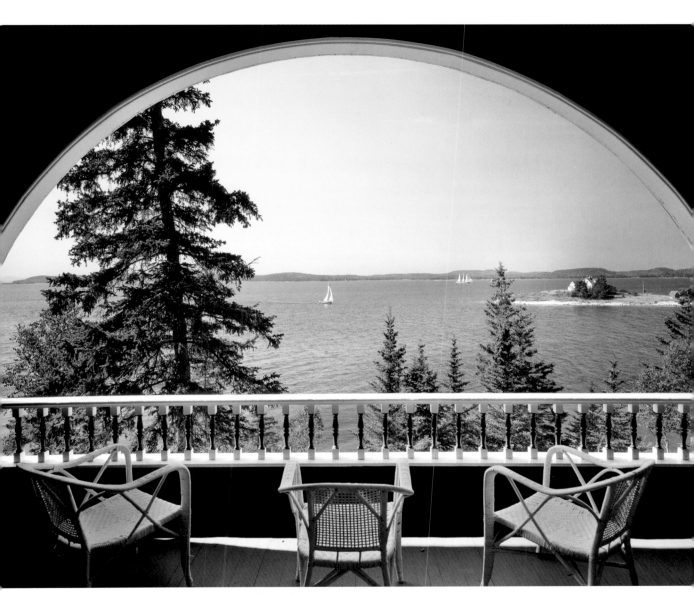

Left: Coastal Rhode Island; above: Little Deer Isle, Maine

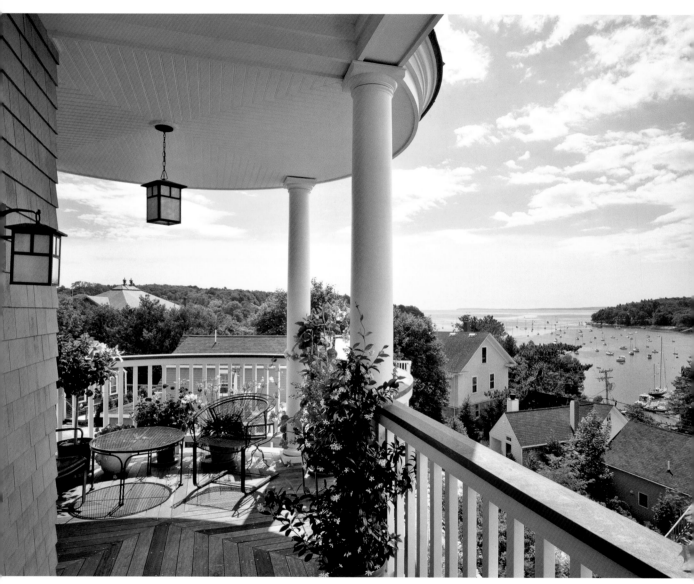

Above: Rockport, Maine; right: Coastal Maine

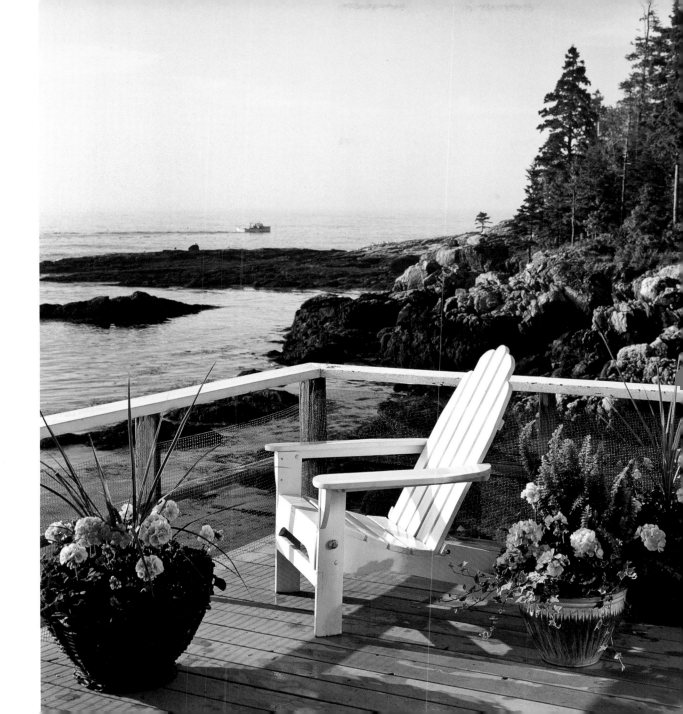

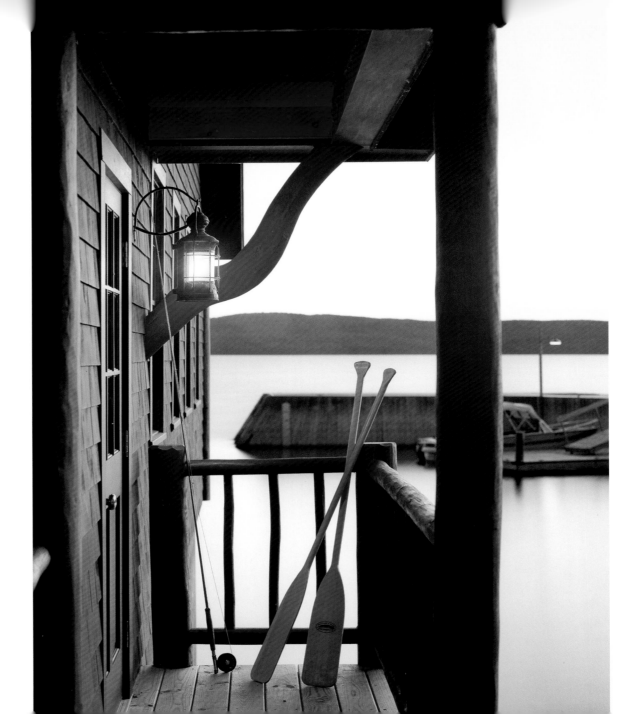

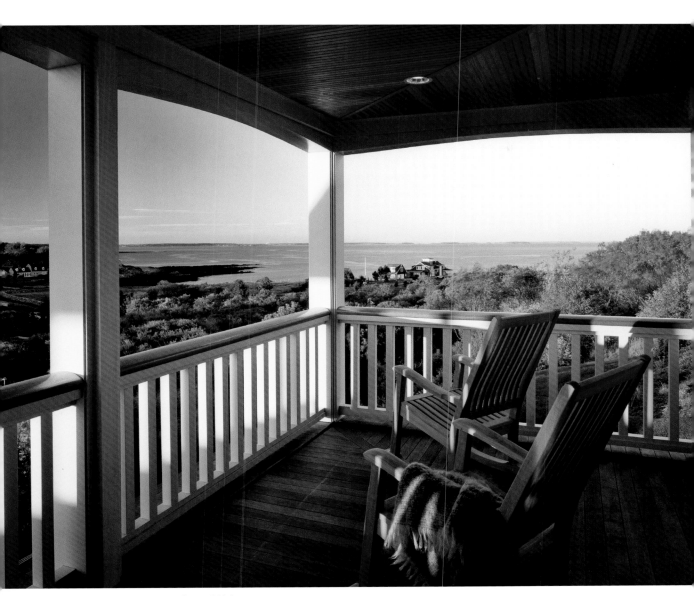

Left: Western Maine; above: Coastal Maine

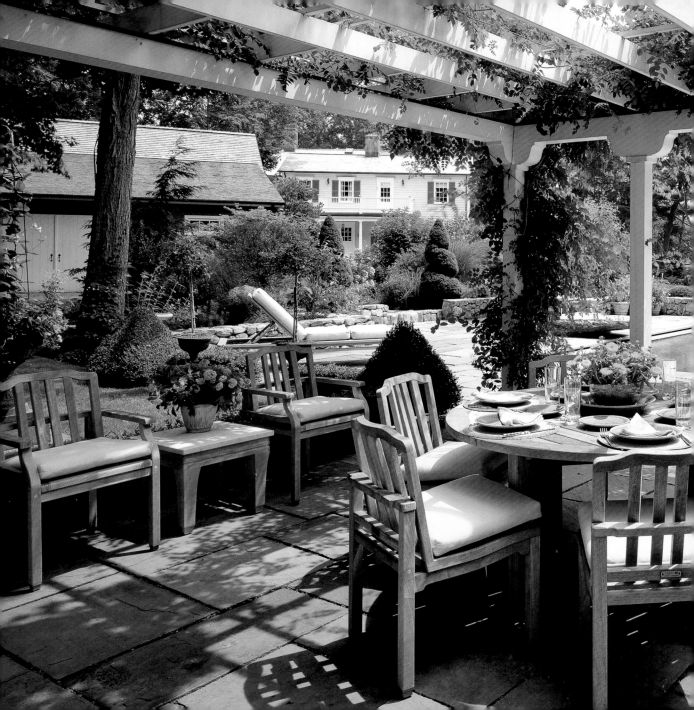

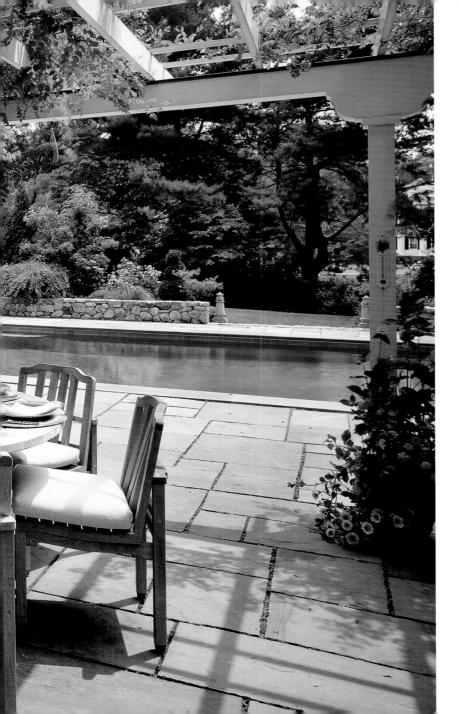

A roomy porch is a
dining room nonpareil.

Coastal Connecticut

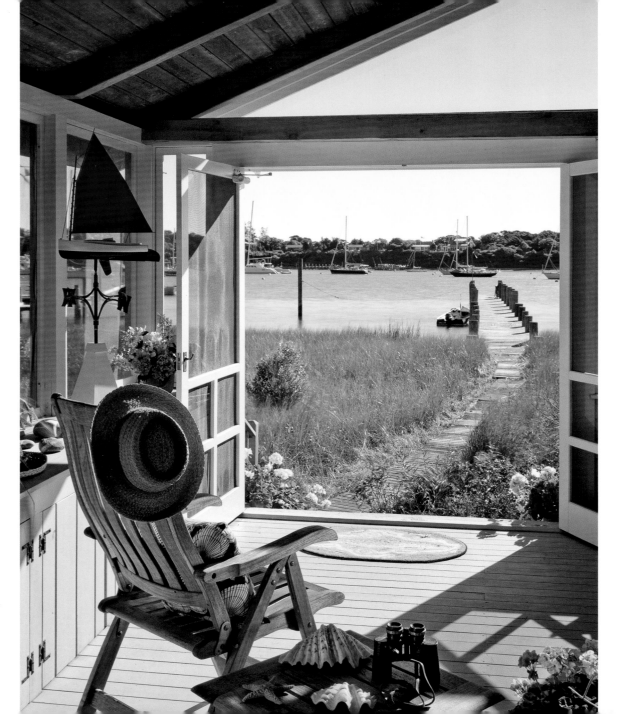

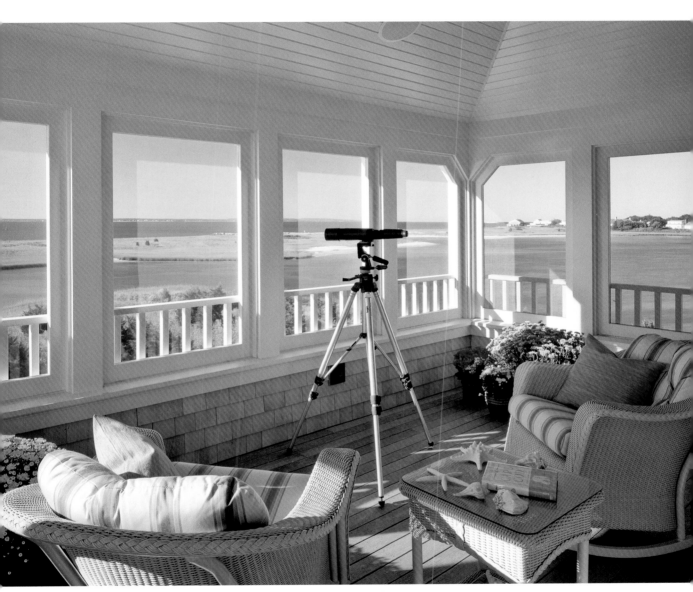

Left: Martha's Vineyard, Massachusetts; above: Martha's Vineyard, Massachusetts

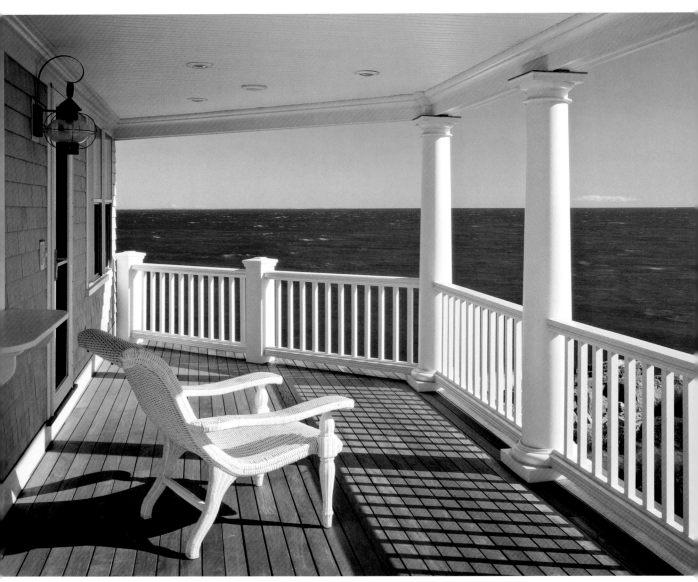

Above: South Shore, Massachusetts; right: Coastal Maine

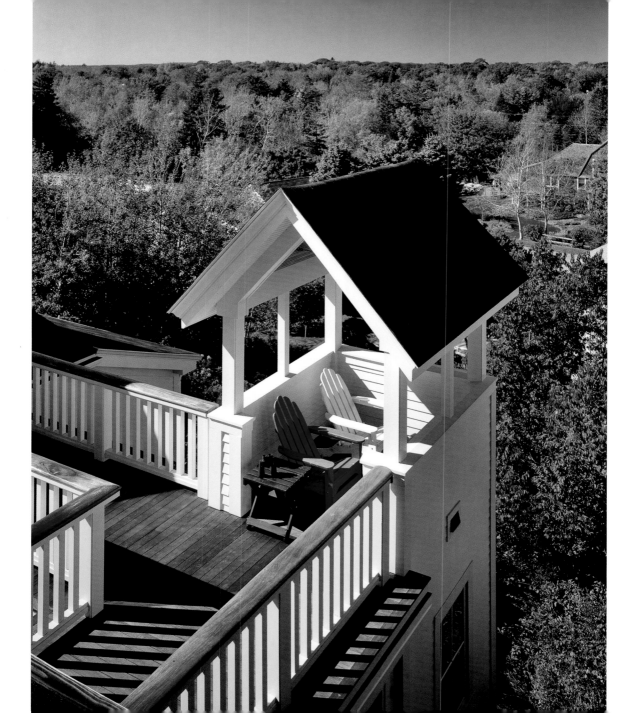

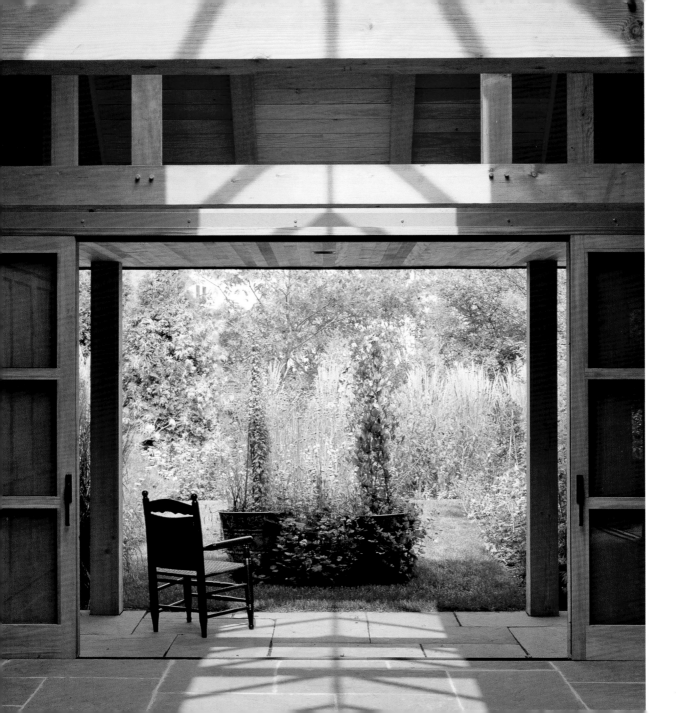

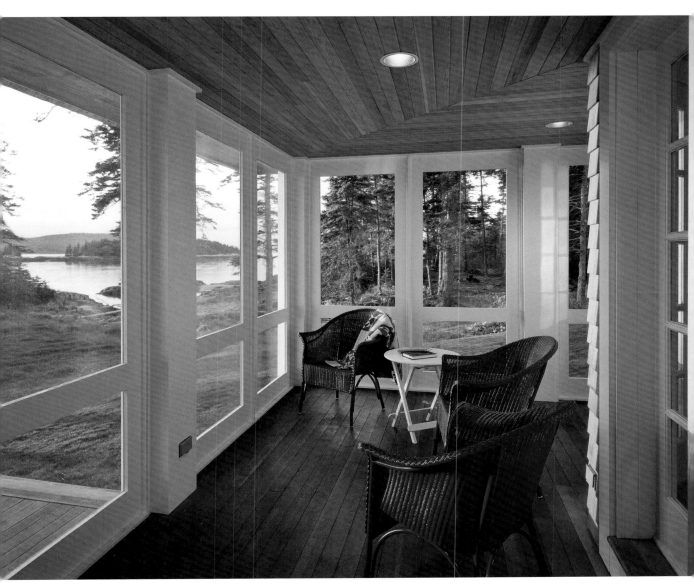

Left: Coastal Maine; above: Coastal Maine

The best porches

feel inevitable. You can-
not imagine the house
without them. Often
this is a matter of origi-
nal intention—e.g., an
elaborate wraparound
porch intimately con-
nected to the shape
and style of the house.
But it can also arise by
inspired afterthought. A
well-designed add-on
porch can lend charac-
ter to a simple, block-like
structure. Equally, a quiet
outdoor sitting area can
make a grand, imposing
edifice feel homey.

North Shore, Massachusetts

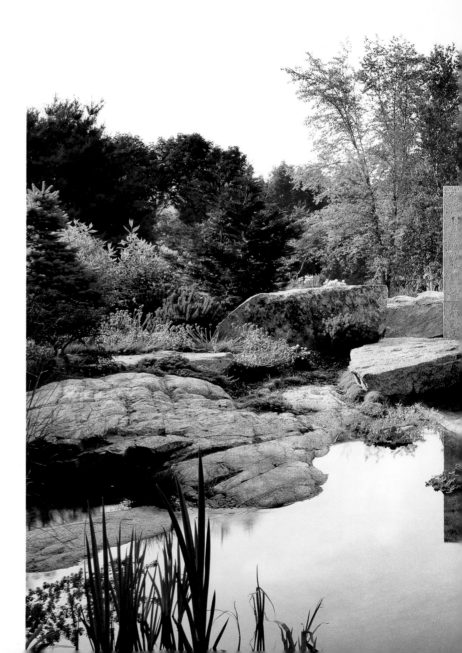

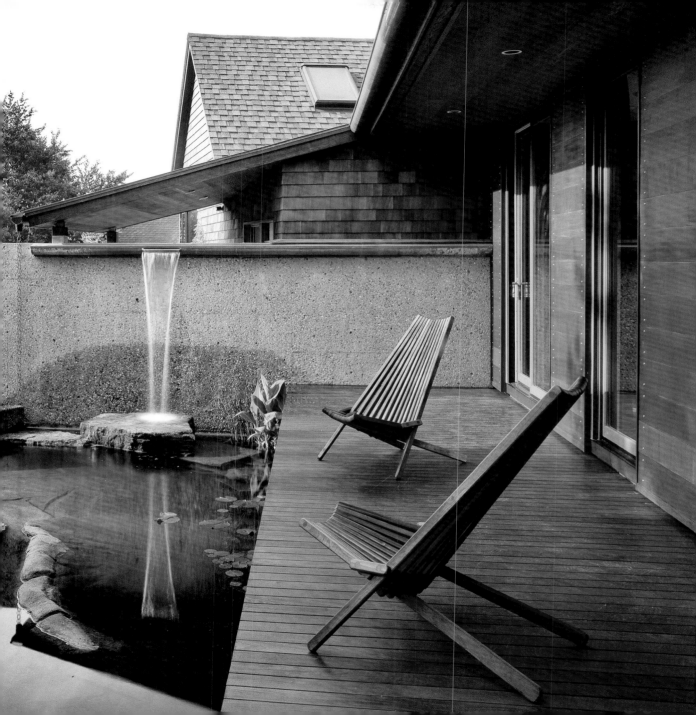

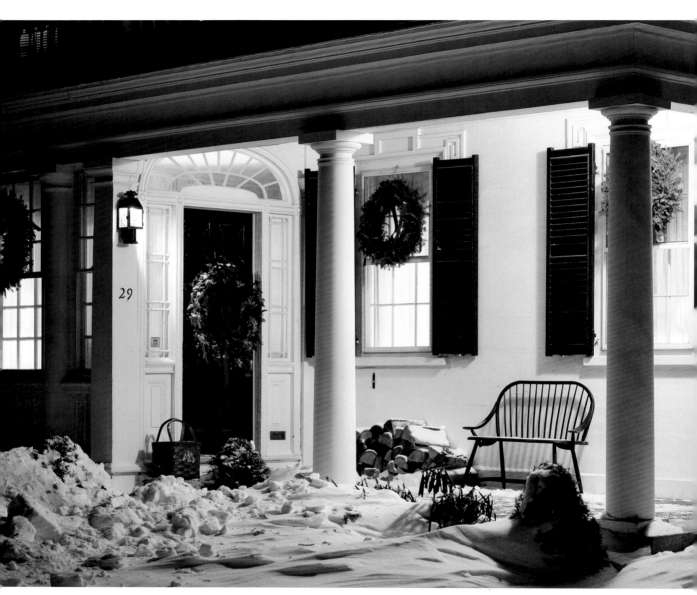

Above: Kennebunk, Maine; right: Garrison, New York

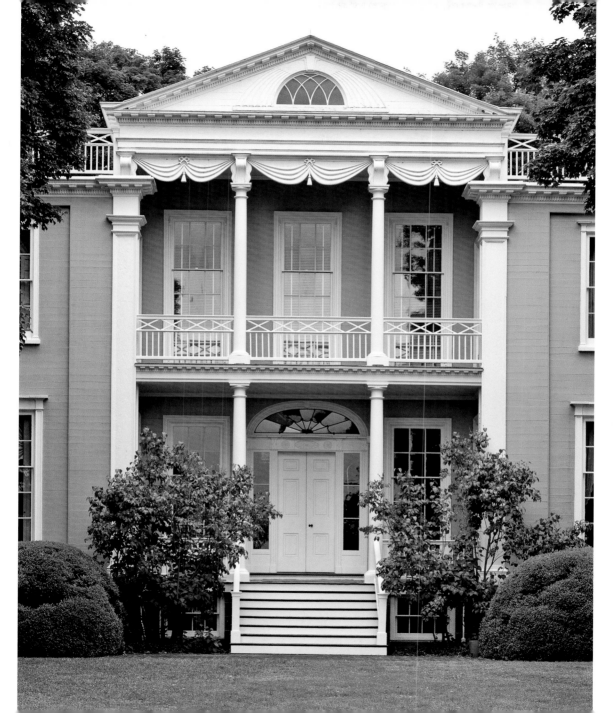

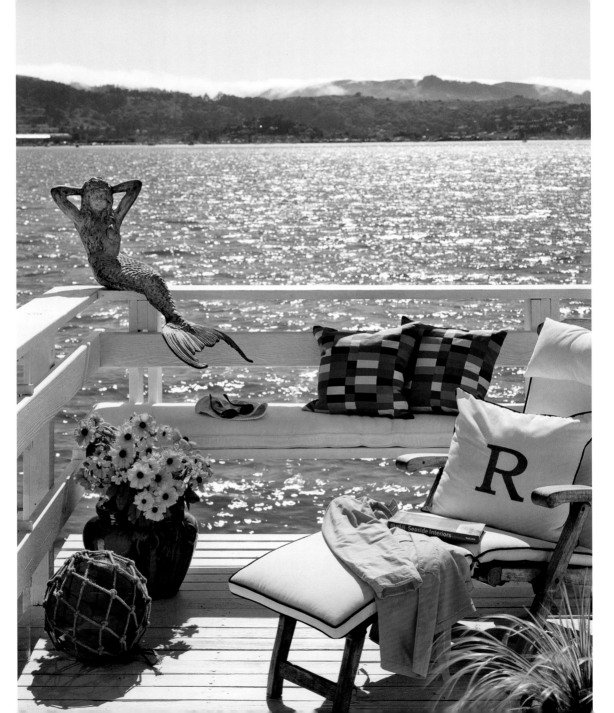

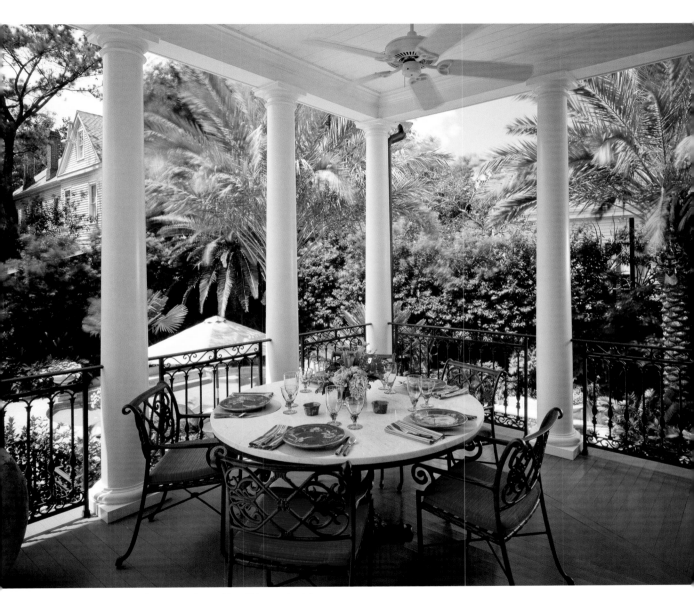

Left: San Francisco, California; above: New Orleans, Louisiana

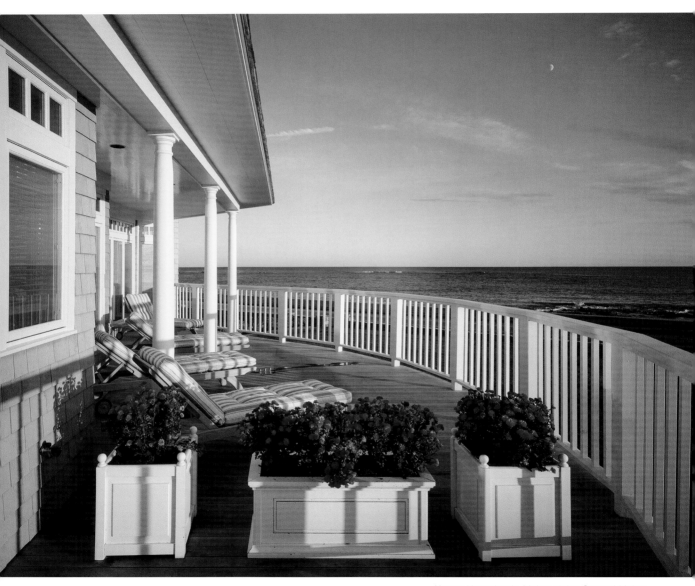

Above: Kennebunk, Maine; right: Coastal Maine

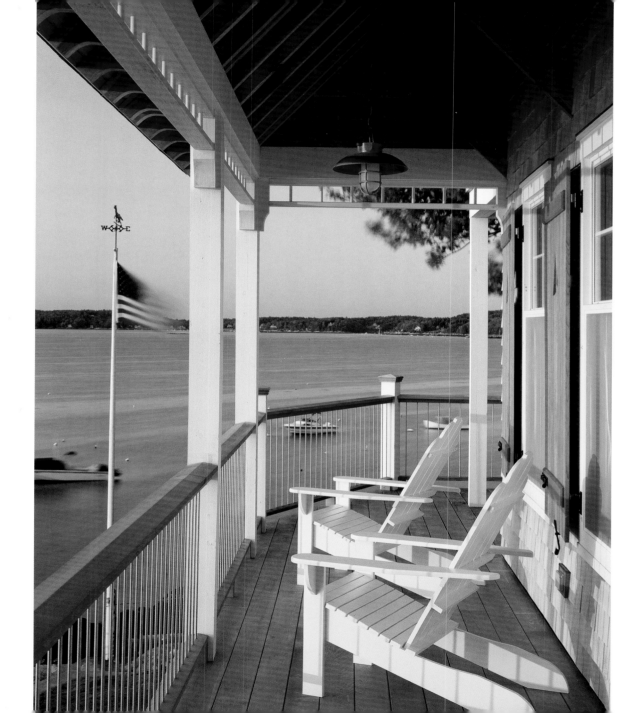

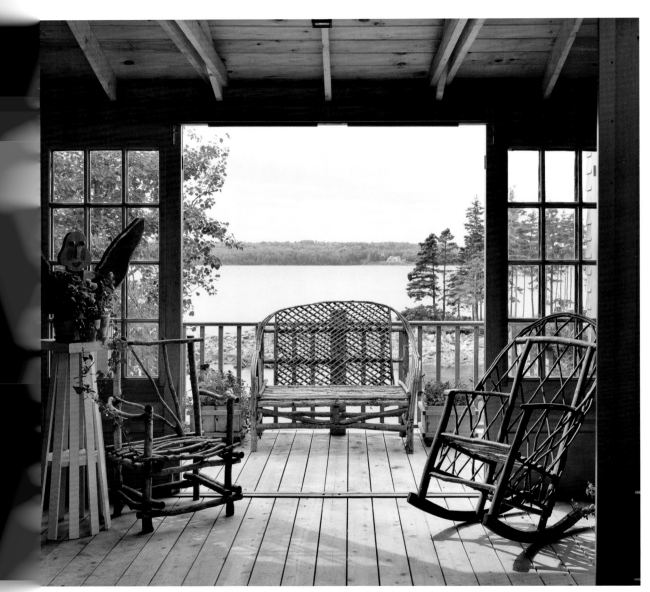

Above: Mount Desert Island, Maine; right: Coastal Maine

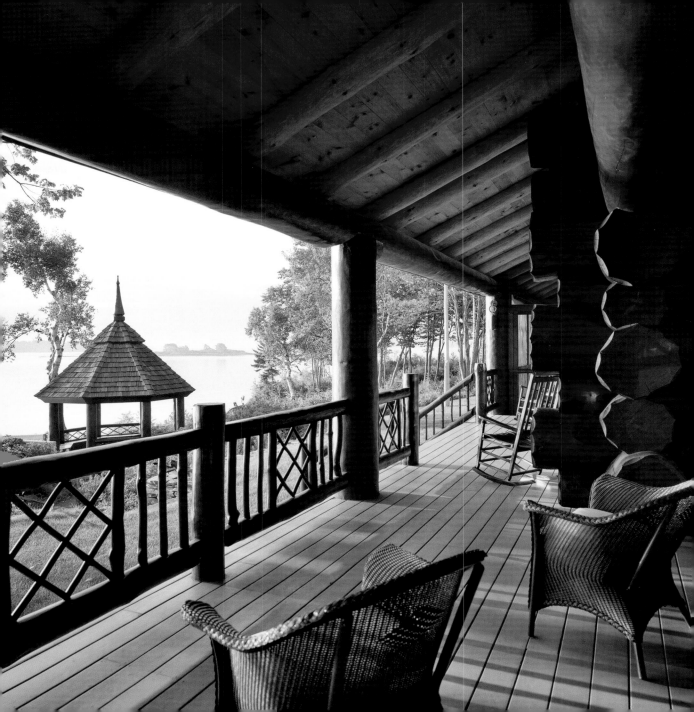

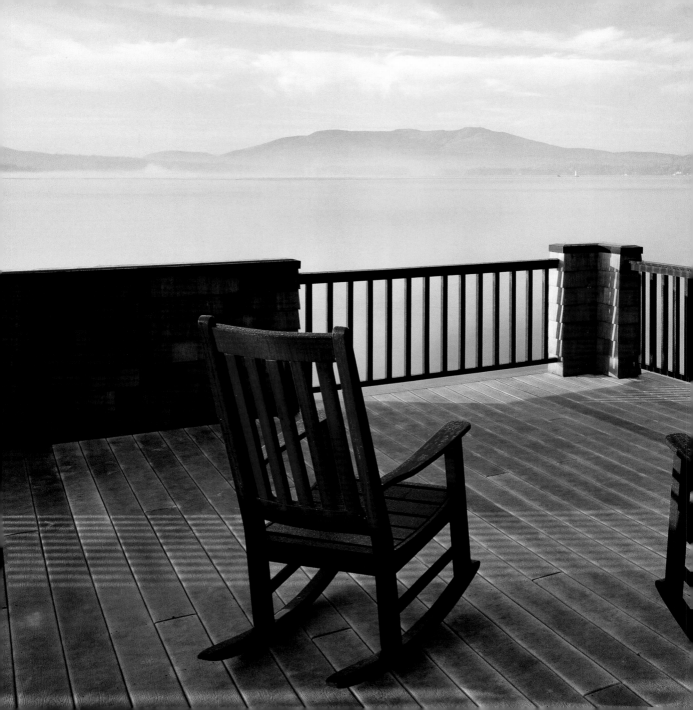

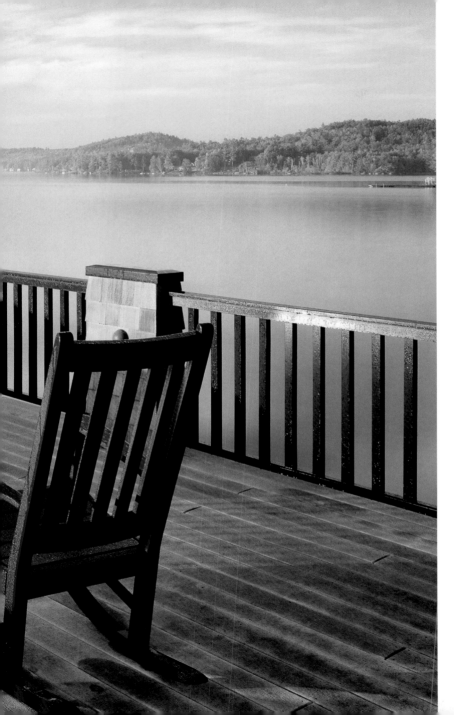

How do you compete with a stunning natural vista? Well, you don't. Except for providing some degree of shelter from the elements, a porch is probably best regarded as a vantage point. It ought to feel, at a minimum, safe, comfortable, and firmly anchored to the house—a quiet balance between the sanctuary of home and the unbounded wildness of nature. Exhilaration is a fine thing, but a little goes a long way. The porch, in such a setting, is a place to rein things in.

New Hampshire lake

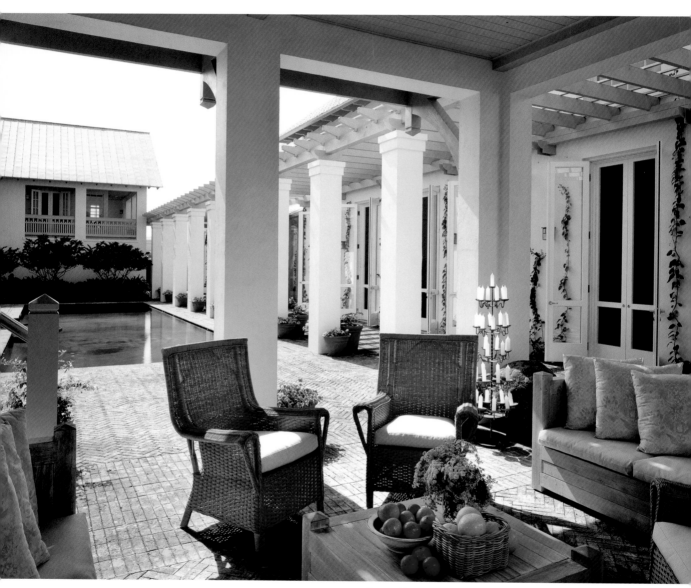

Above: Melbourne, Florida; right: Hilton Head, South Carolina

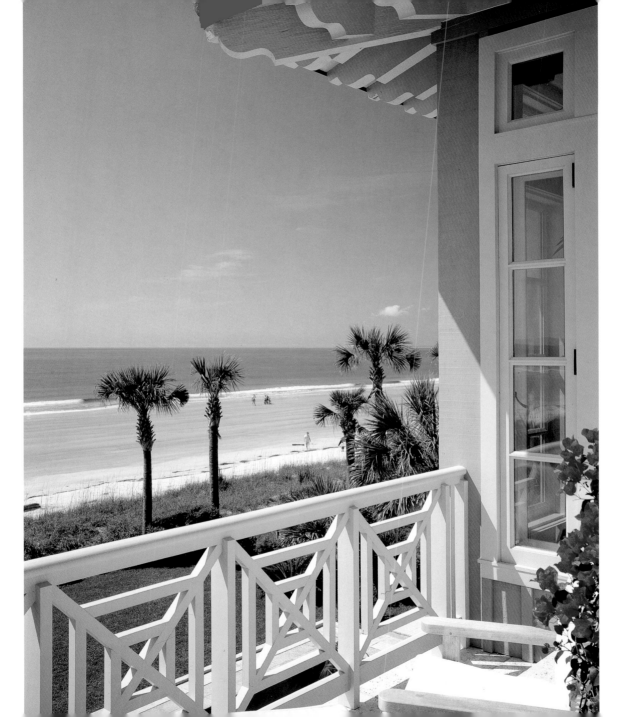

A cheerful front porch conveys a spirit of welcome, of warmth, of spontaneous hospitality. It beckons friend and stranger alike, promising all the good things of life just inside the door.

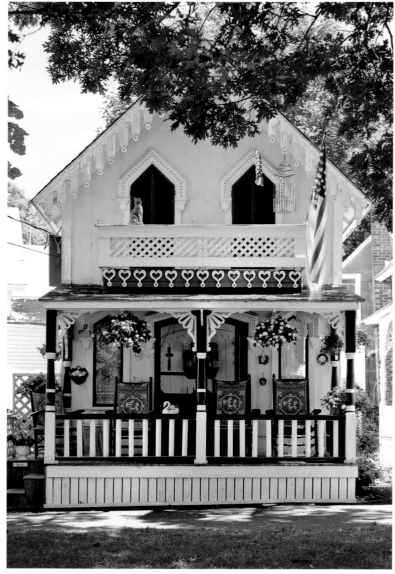

Oak Bluffs, Martha's Vineyard, Massachusetts

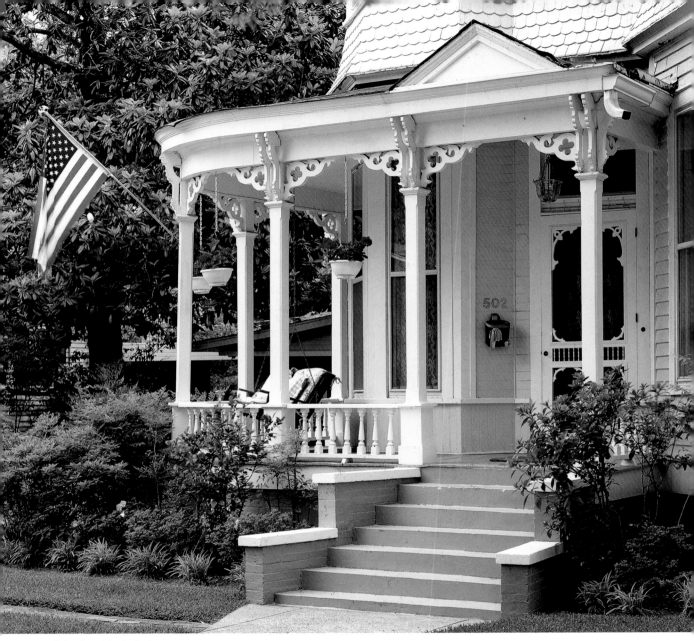

Columbus, Mississippi

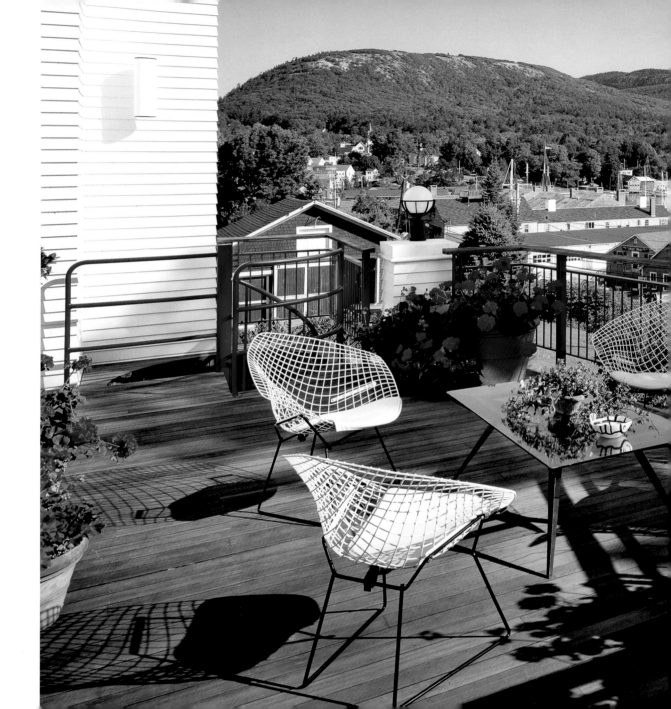

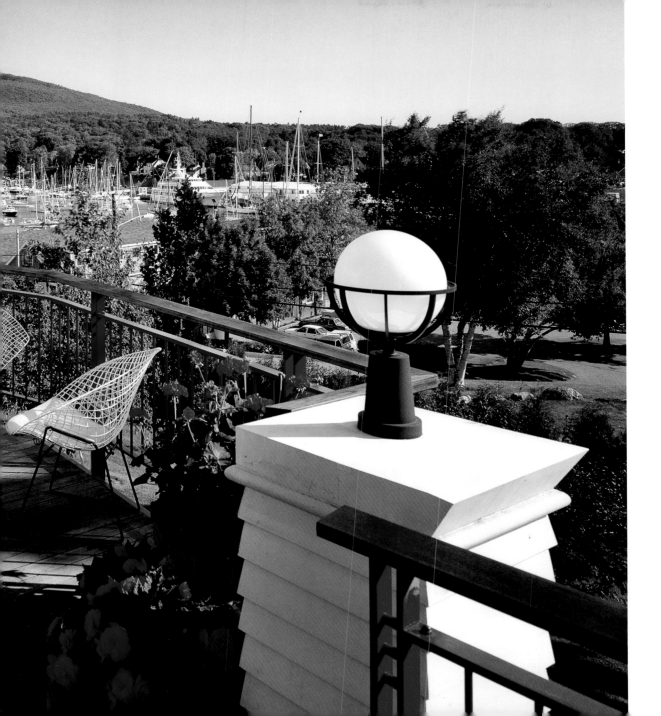

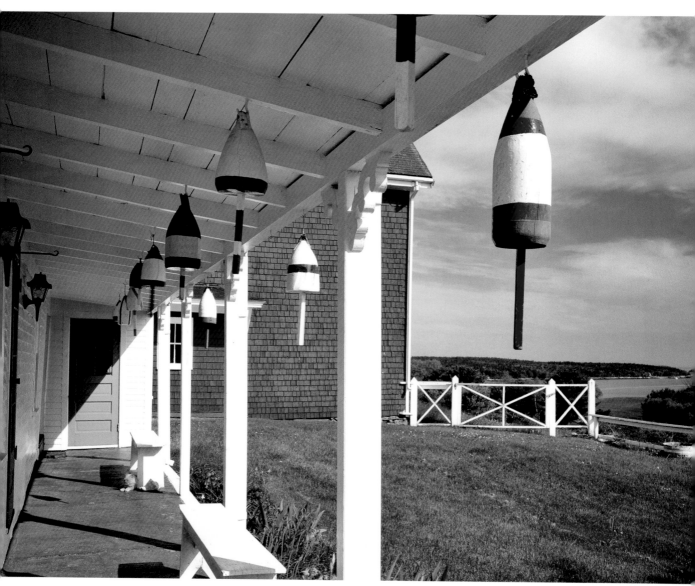

Previous: Camden, Maine; above: Walpole, Maine; right: North Haven, Maine

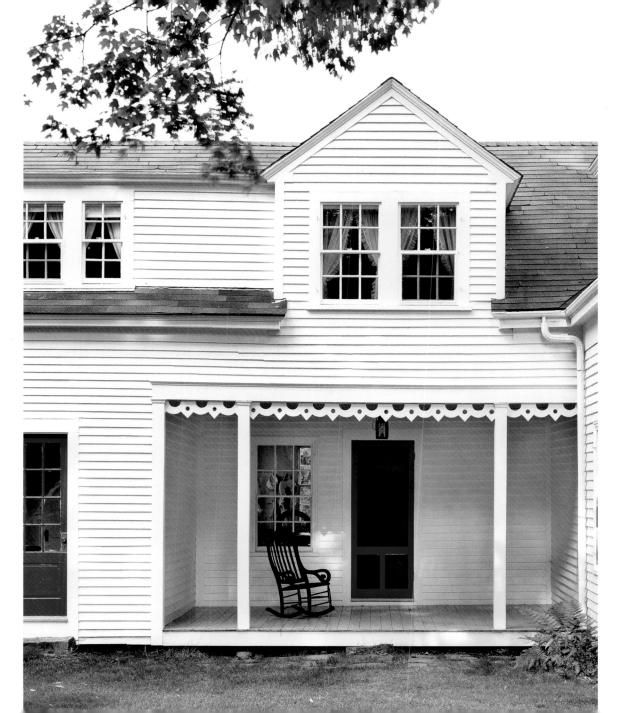

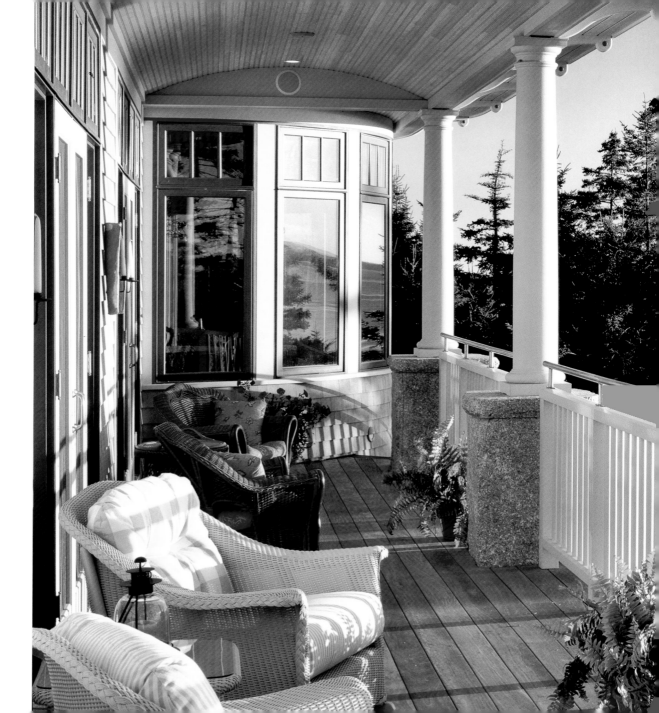

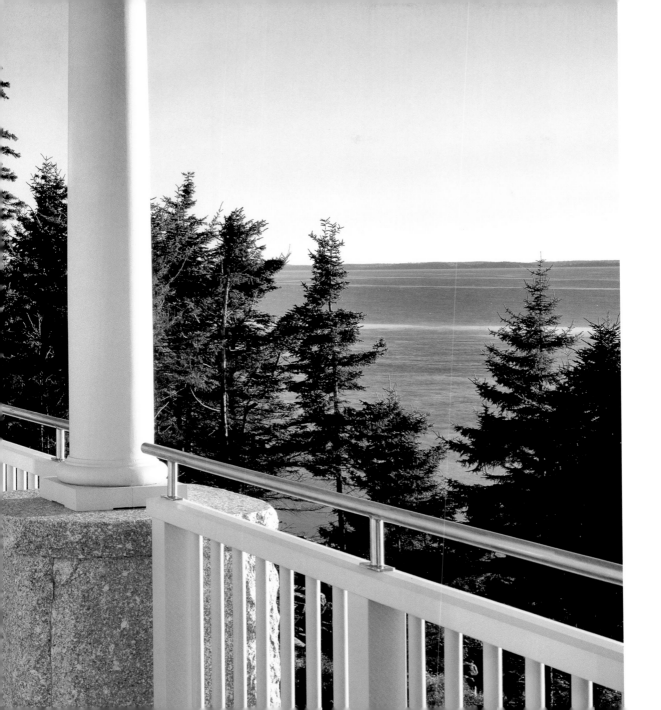

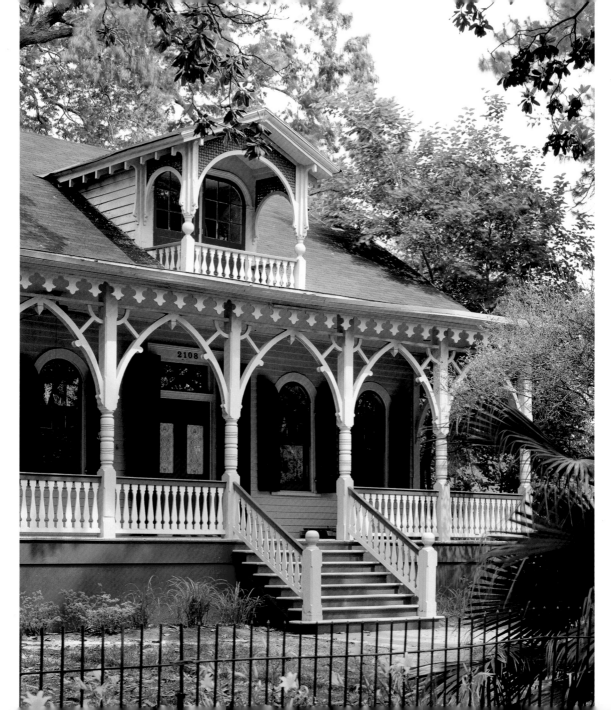

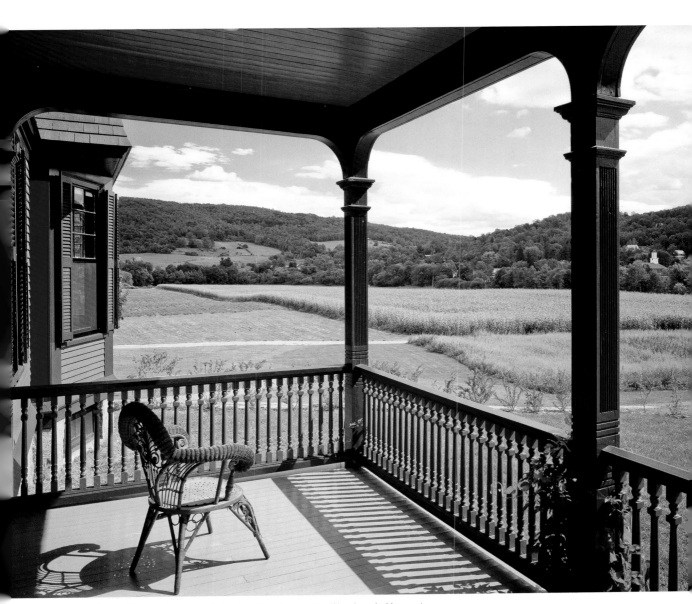

Previous: **Coastal Maine**; left: New Orleans, Louisiana; above: Woodstock, Vermont

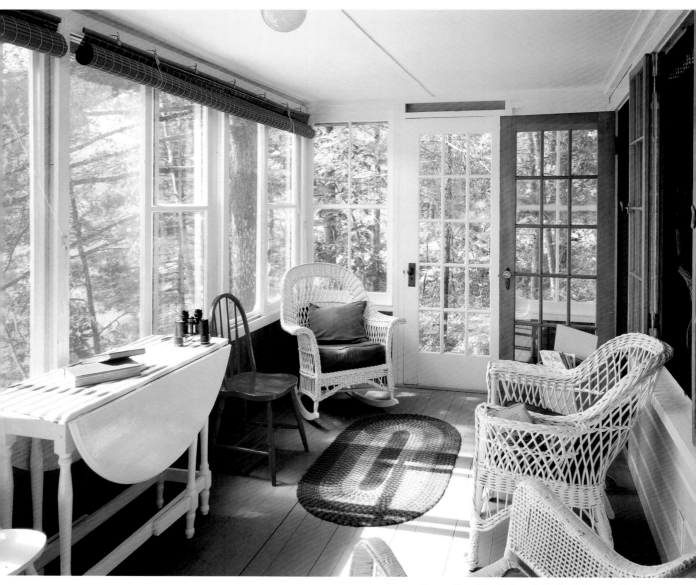

Above: Camden, Maine; right: North Haven, Maine

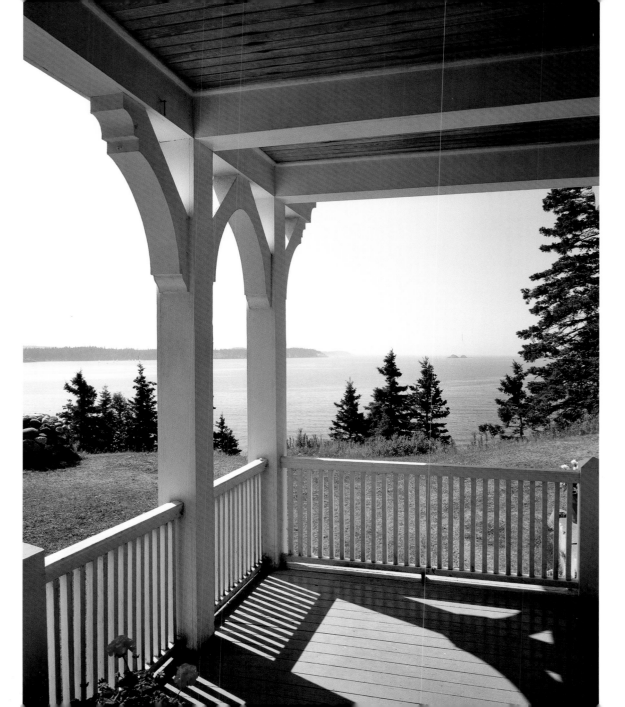

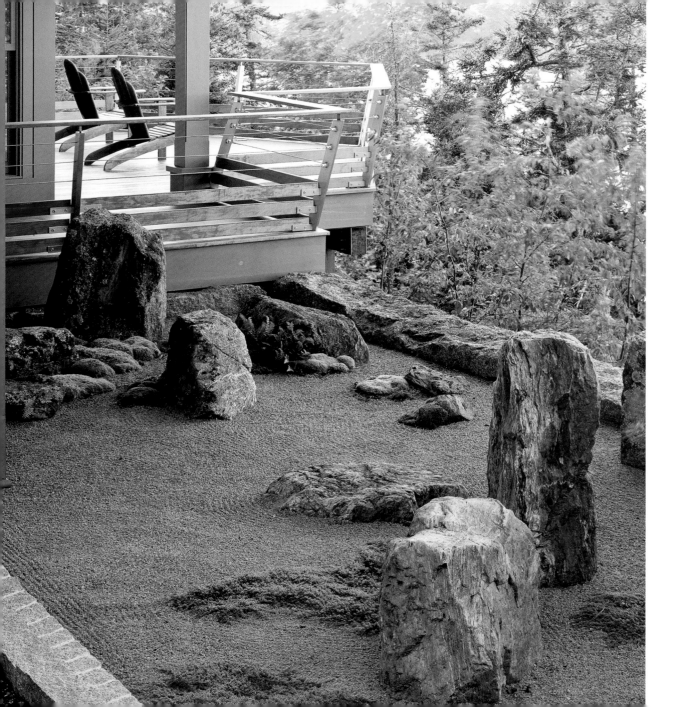

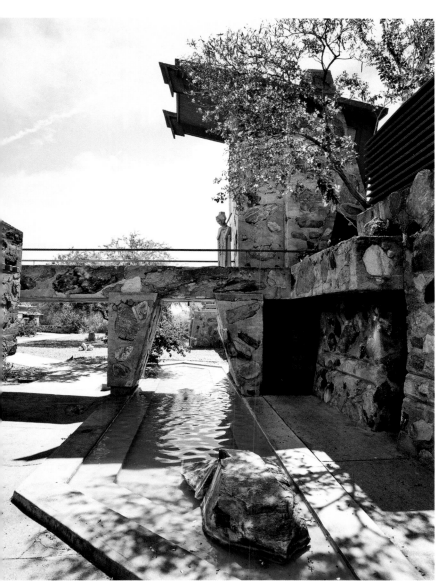

The Zen of porches:

Sometimes furnishing a porch is an exercise in artful omission. A single chair—two at most—may be quite enough. One vase of flowers may hold more drama than mounds of exuberant blossom. A pillow on a bare deck can seem more luxurious than an overstuffed sofa. Let nature provide the complexity, the color, the excitement. Let the porch be an island of serenity.

Left: Coastal Maine; above: Scottsdale, Arizona

With the advent
of the Shingle Style, the
porch attained a dignified
solidity that reinforced
the physical presence
of the house. It seemed
to buttress, rather than
merely augment, the
structure as a whole.
Broad pillars, protective
half-walls, bomb-proof
overhangs—this kind of
porch is a room in an
almost literal sense.

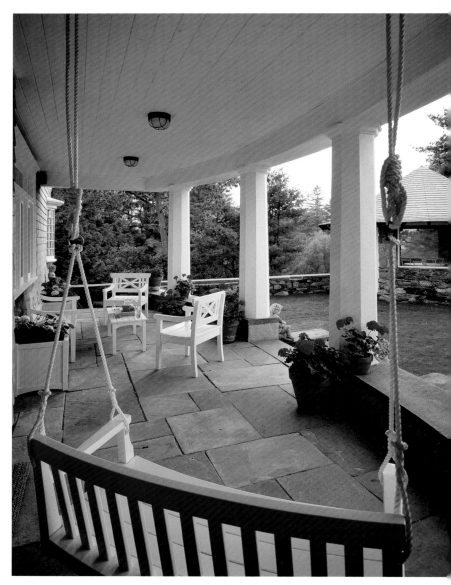

Above: Rural Connecticut; right: Coastal Maine

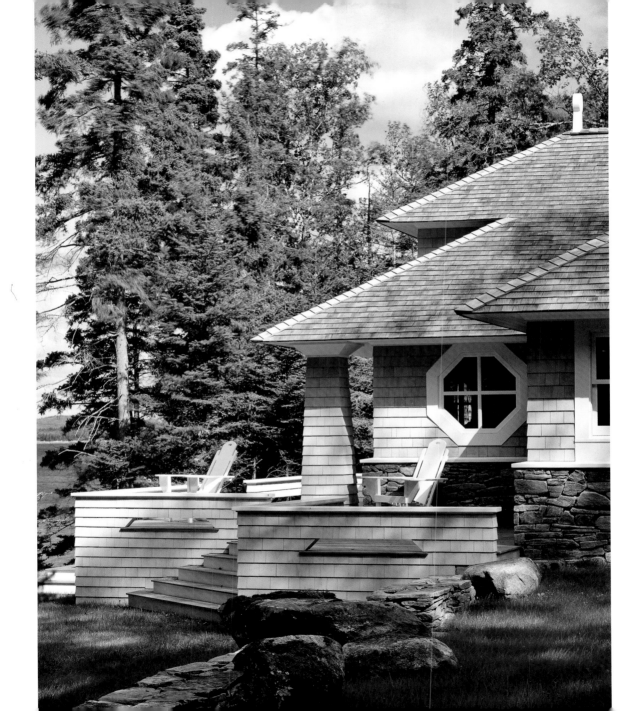

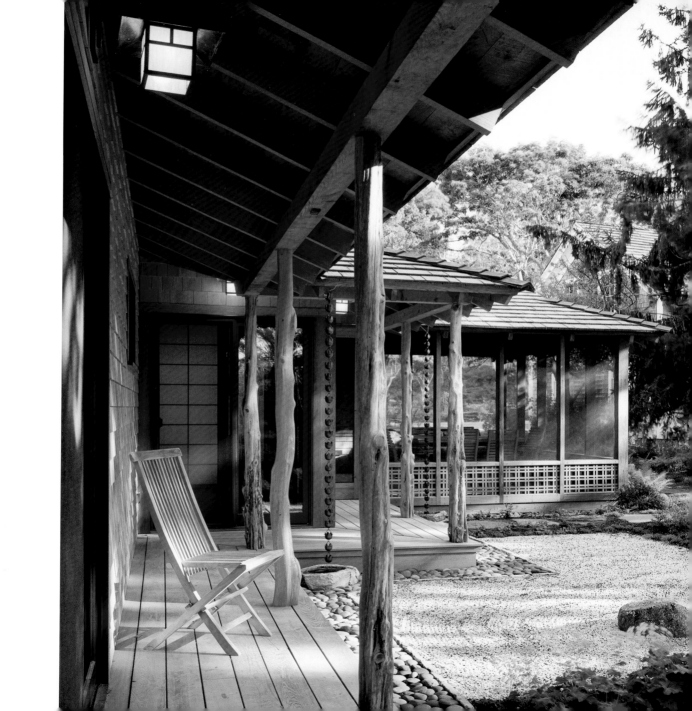

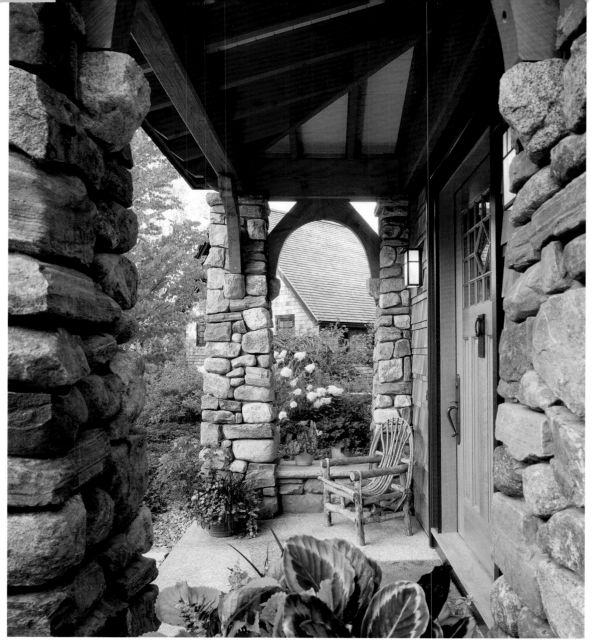

Left: Martha's Vineyard, Massachusetts; above: Coastal Maine

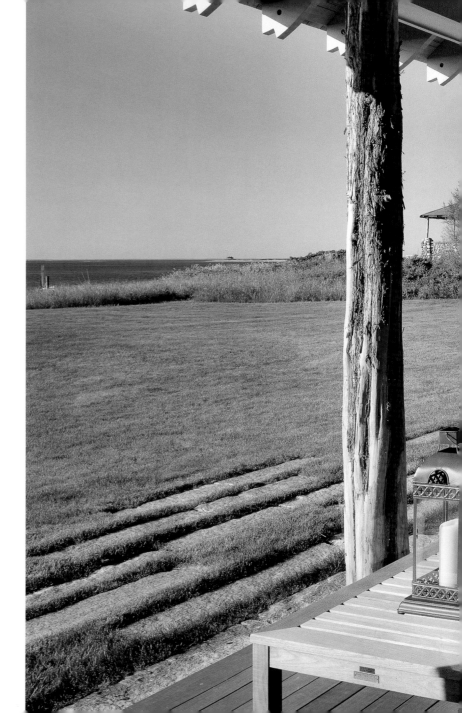

Good porches,

like good wines, improve
with age. The weathered-
in look is part of the
charm.

Chappaquidick Island,
Massachusetts

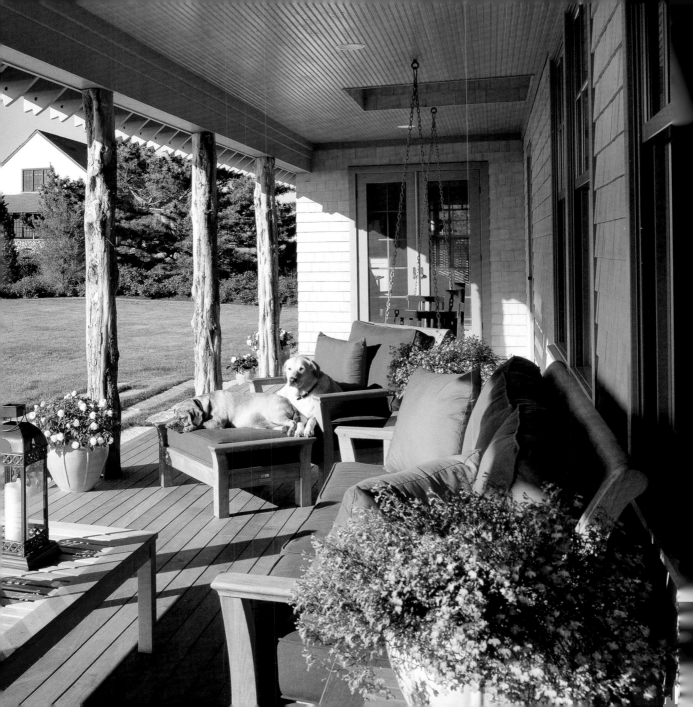

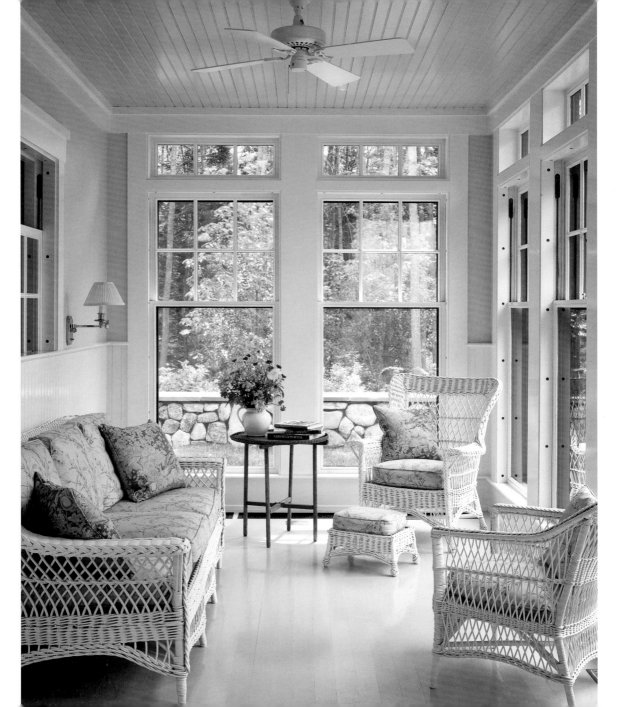

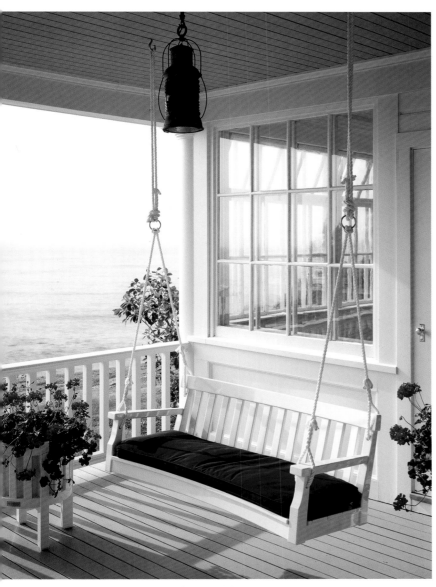

The art of porch-making entails striking a balance—often a playful one—between concealment and openness, modesty and exposure. It's hardly surprising that the Victorians played the game with such panache.

Left: Blue Hill, Maine; above: Coastal Maine

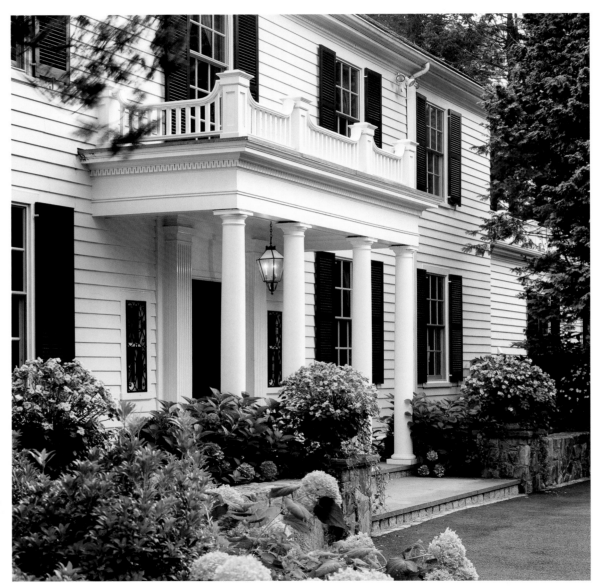

Above: North Shore, Massachusetts; right: Hilton Head Island, South Carolina

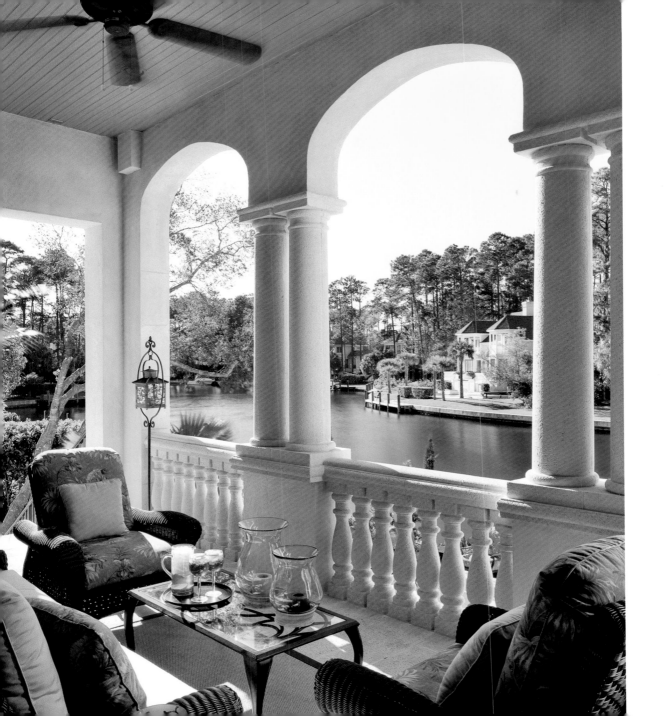

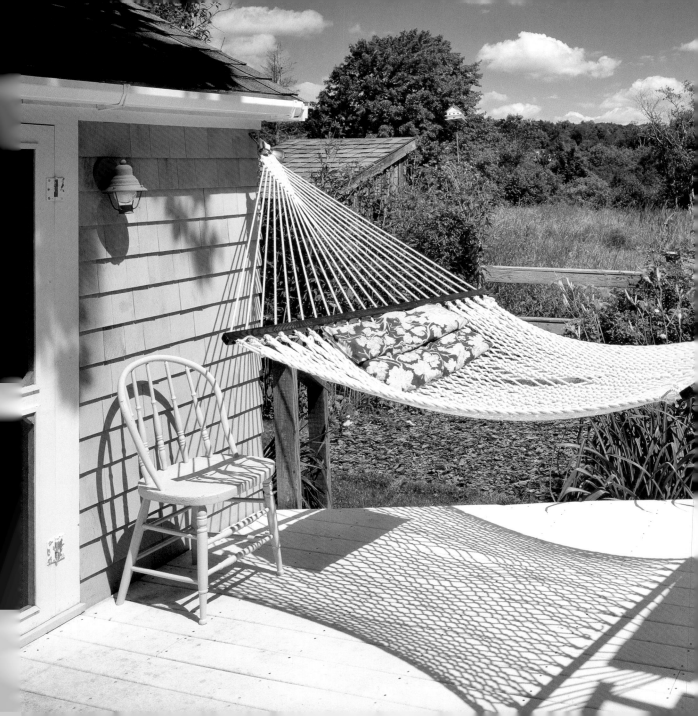

The science of porch design is governed by an unwritten law that most people intuitively grasp: The more magnificent the setting, the simpler the porch can be. There is no need (and no way) to compete with an eye-popping view. Just set some chairs out, hang a hammock, design some bold but simple plantings. The converse also applies: The more modest the setting, the showier the porch can become. For a small rustic cabin, the porch may be the single note of decorative splendor.

Round Pond, Maine

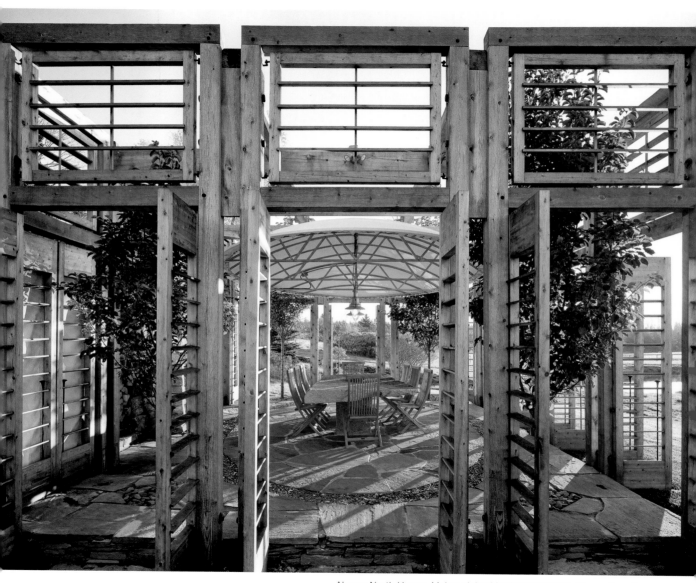

Above: North Haven, Maine; right: Martha's Vineyard, Massachusetts

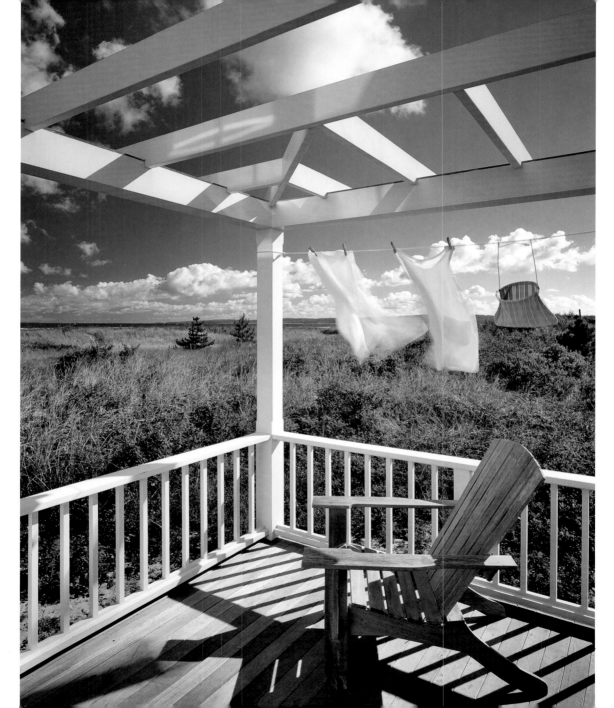

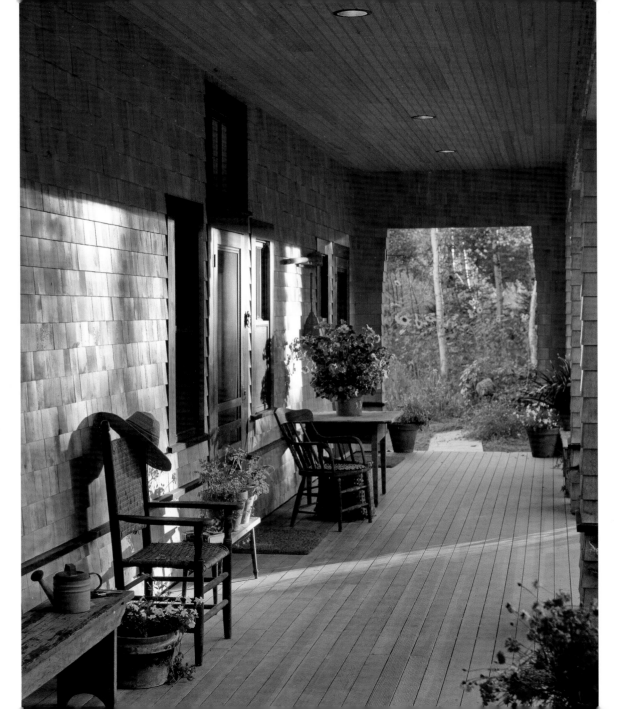

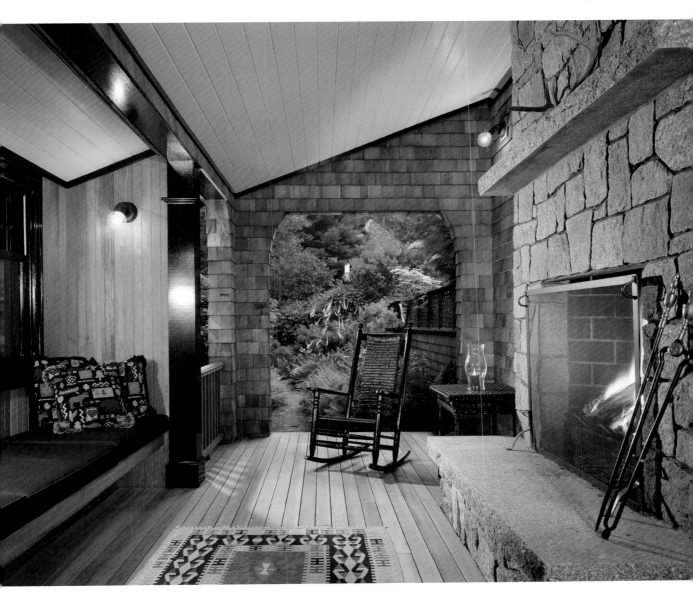

Left: Tenants Harbor, Maine; above: Northeast Harbor, Maine

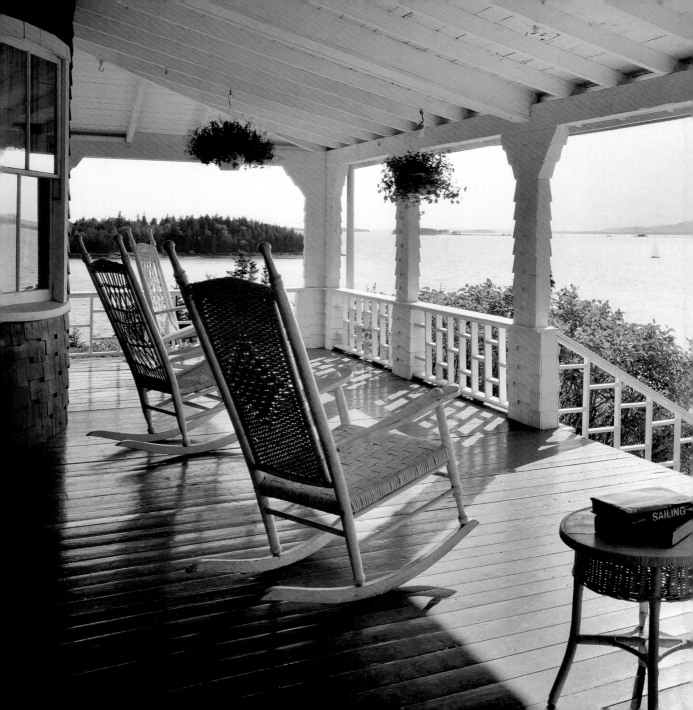

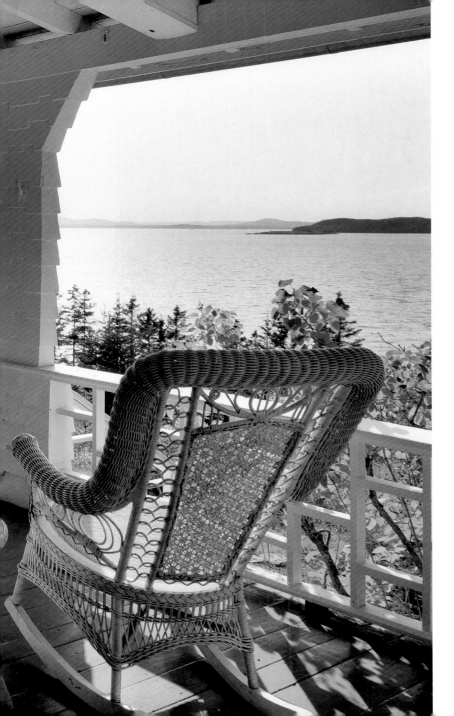

**"I'm an old-
fashioned guy...**
I want to be an old man
with a beer belly sitting
on a porch, looking at a
lake or something."

—Johnny Depp
b. 1963, American actor

Little Deer Isle, Maine

Porch design credits

(where known)

2–3	Stephen Blatt Architects		**48**	Carol Wilson, Architect
4	John Gillespie, Architect		**49**	Silverio Architecture & Design
8	Phi Home Designs		**50–51**	Robinson & Grisaru Architecture
9	Perry Dean Rogers Partners Architects		**55**	George Workman, Landscape Architect
10	Scott Simons Architects		**56**	Winton Scott, Architect
11	Seimasko and Verbridge		**57**	Whitten Architects
12	Elliot & Elliot Architecture		**58**	Bernhardt & Priestly Architecture
13	Stephen Blatt Architects		**59**	Bullock and Company Builders
14	Hutker Architects		**60–61**	Shope Reno Wharton Architecture
15	Orcutt Associate Architects		**62**	Payette Associate Architects
16	Stephen Blatt Architects		**63**	Group 3
17	Whitten Architects		**70–71**	Elliot & Elliot Architecture
20	Hutker Architects		**73**	Northern Architects
21	Will Winkelman, Architect		**76**	Jeremiah Eck, Architect
23	Sally Weston, Architect		**77**	Frank Lloyd Wright
24–25	Scott Simons Architects		**79**	Silverio Architecture & Design
27	Peter Rose and Partners		**80**	South Mountain Company
28	Howell Custom Building Group		**81**	Bernhardt & Priestly Architecture, George Workman, Landscape Architect
29	Albert Richter and Tittman Architects		**82–83**	Albert Richter and Tittman Architects
32–33	Whitten Architects		**84**	Elliot & Elliot Architecture
34–35	Bernhardt & Priestly Architecture		**85**	Weatherend Estate Furniture
36	Shope Reno Wharton Architecture		**86**	Dominic Mercadante, Architect
38	Bernhardt & Priestly Architecture		**87**	Group 3
40	Whitten Architects		**90**	Sam Williamson, Landscape Architect
41	Stephen Blatt Architects		**91**	Hutker Architects
45	Hutker Architects		**92**	Silverio Architecture & Design
46	Fabrizio Construction		**93**	Albert Richter and Tittman Architects
47	Stephen Blatt Architects			